NUMISMATIC NOTES AND MONOGRAPHS

No. 165

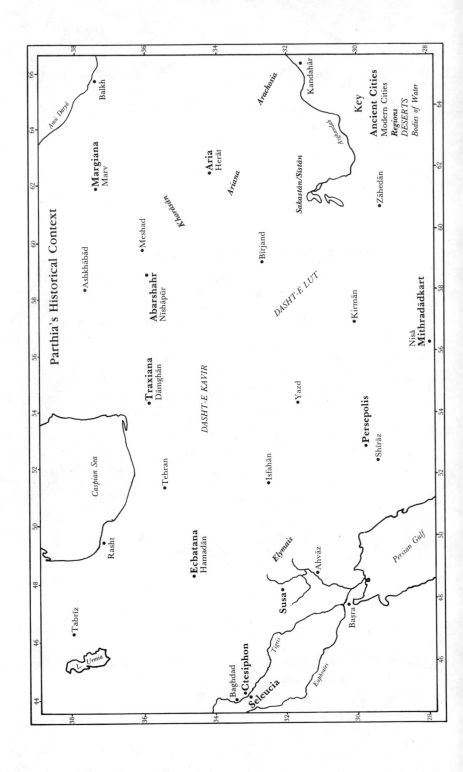

Parthia's Historical Context

Key

Ancient Cities
Modern Cities
Regions
DESERTS
Bodies of Water

Balkh

Amu Darya

Margiana
Marv

Ashkhābād

•Meshad

Khorāsān

Abarshahr
Nishāpūr

Aria
Herāt

Ariana

Arachosia

Kandahār

Arghandāb

•Zāhedān

Sakastan/Sistān

•Birjand

DASHT-E LUT

Traxiana
Dāmghān

•Kirmān

Nisā
Mithradādkart

DASHT-E KAVIR

•Tehran

Caspian Sea

•Yazd

•Isfahān

Persepolis
•Shirāz

Rasht

•Tabrīz

L. *Urmia*

Ecbatana
Hamadān

Elymais

•Ahvāz

Susa•

Persian Gulf

Basra

Tigris

Baghdad•
•**Ctesiphon**

Seleucia

Euphrates

A HOARD OF COINS FROM EASTERN PARTHIA

BY HEIDEMARIE KOCH

THE AMERICAN NUMISMATIC SOCIETY, NEW YORK

THE J. PAUL GETTY MUSEUM, MALIBU, CALIFORNIA

1990

PRINTED IN BELGIUM AT CULTURA, WETTEREN

TABLE OF CONTENTS

PREFACE

In the spring of 1982, my husband Guntram and I were able to spend two months in Malibu at the invitation of the Getty Museum. We would like to thank the Trustees, Stephen Garrett (then Director), Jiří Frel (then Curator of Antiquities), and Laurie Fusco (of the Academic Affairs Department), for this unforgettable stay.

My special thanks are to Jiří Frel who drew to my attention the Museum's unusual hoard of eastern Parthian coins and who entrusted me with work on them.

Thanks are due to Donald Hull and Penelope Potter for the photographing of the coins, to Marit Jentoft-Nilsen and Renate Dolin for their untiring help, to Melanie Richter-Bernburg for the excellent translation of the text, and to Christoph Boehringer, Arthur Houghton, and William F. Spengler for their scholarly advice in the field of numismatics.

We would like to extend our warmest thanks to all the members of the staff at the Museum for the friendly help and support they gave us while we were in Malibu, especially Jiří Frel and Faya Causey who did much to make it possible for us to get to know California and its people better.

Heidemarie Koch
Marburg

ABBREVIATIONS

Allotte de la Fuÿe	Allotte de la Fuÿe, *Monnaies de l'Élymaïde* (Chartres, 1905)
BSOAS	*Bulletin of the School of Oriental and African Studies,* University of London
CHI 3, 1	E. Yarshater, ed., *The Cambridge History of Iran,* vol. 3, pt. 1, *The Seleucid, Parthian and Sasanian Periods* (London, 1983)
CHI 3, 2	E. Yarshater, ed., *The Cambridge History of Iran,* vol. 3, pt. 2, *The Seleucid, Parthian and Sasanian Periods* (London, 1983)
Colledge	M. A. R. Colledge, *The Parthians* (London, 1967)
Debevoise	N. Debevoise, *A Political History of Parthia* (Chicago, 1938)
Dobbins	K. W. Dobbins, "Sanabares and the Gondophares Dynasty," *NC* 1971, pp. 135–42
Gardner *BMC*	P. Gardner, *BMC Greek and Scythic Kings of Bactria and India* (London, 1886)
Göbl 1962	R. Göbl, *Die Münzen der Sasaniden* (The Hague, 1962)
Göbl 1968	R. Göbl, *Sasanidische Numismatik,* Handbücher der mittelasiatischen Numismatik 1 (Brunswick, 1968)
Göbl 1	R. Göbl, *Antike Numismatik* 1 (Munich, 1978)
Göbl 2	R. Göbl, *Antike Numismatik* 2 (Munich, 1978)

Hill *BMC*

F. Hill, *BMC Greek Coins of Arabia, Mesopotamia and Persia* (London, 1922)

Kahrstedt

U. Kahrstedt, *Artabanos III. und seine Erben* (Bern, 1950)

Le Rider

G. Le Rider, *Suse sous les Séleucides et les Parthes, Mission de Susiane,* Mémoires de la délegation archéologique en Iran 38 (1965)

Mitchiner, *Ancient World*

M. Mitchiner, *The Ancient and Classical World, 600 B.C. – A.D. 650. Oriental Coins and Their Values* (London, 1978)

Mitchiner, *Indo-Parthians*

M. Mitchiner, *Indo-Greek and Indo-Scythian Coinage,* vol. 8, *The Indo-Parthians* (London, 1976)

"Monnaies des rois Elymaïde"

G. Le Rider, "Monnaies à légende grecque et monnaies des rois Elymaïde," *Mission de Susiane,* Mémoires de la délegation archéologique en Iran 37 (1960), pp. 3-37, pls. 1–5

Paruck

F. D. J. Paruck, *Sasanian Coins* (rpt. Delhi, 1976)

Petrowicz

A. von Petrowicz, *Arsaciden Münzen* (rpt. Graz, 1968)

Schippmann

K. Schippmann, *Grundzüge der parthischen Geschichte* (Darmstadt, 1980)

Sellwood

D. Sellwood, *An Introduction to the Coinage of Parthia* (rpt. London, 1980)

Simonetta 1957

A. Simonetta, "An Essay on the So-Called 'Indo-Greek' Coinage," *East and West* 8 (1957), pp. 44–66

Simonetta 1978

A. Simonetta, "The Chronology of the Gondopharean Dynasty," *East and West* 28 (1978), pp. 155–87

Wroth *BMC*

W. Wroth, *BMC Parthia* (London, 1903)

INTRODUCTION

Some years ago, the J. Paul Getty Museum was given a single find of 266 copper coins that was inventoried as part of 75.NI.109. According to oral reports, the gift came from present-day Iran, there were no silver coins present at the time the find was made, and its composition was unaltered at the time of donation.

At first glance, these small copper coins, most of them poorly preserved, seem unimportant. On closer observation, however, most of them must come from the northeastern part of the Parthian kingdom and therefore from an area whose history is still only vaguely known to us. Insofar as there are literary sources for the history of the Parthians at all, they stem primarily from the Parthians' western neighbors, in particular from the Romans,[1] with whom they were often engaged in armed conflict. The farther east the Parthians were from the border with the Roman Empire, the fewer the extant literary reports. Chinese sources, on the other hand, of which there are scattered instances,[2] are concerned mainly with the provinces bordering on their territories, with the Kushans and the inhabitants of the Indus Valley, so that there is still very little known about eastern Iran which is the provenance of the Getty Museum hoard. The major potential historical source of information on this area is, therefore, numismatic material, of which very little has been published up to now.

[1] See esp. Tacitus, *Ann.*; Strabo; Justinus; Dio Cassius; Ptolemy, Geog.; and Pliny, *HN*. For an annotated bibliography, see G. Widengren, *CHI* 3, 2, pp. 1264–69, who regrets the lack of indigenous historical texts in Parthian history (p. 1261).

[2] For the later part of the Parthian kingdom, see the annals of the second Han Dynasty, of which there is an excerpt preserved in the encyclopedia of Ma-twan-lin (thirteenth century A.D.), O. Franke, *Beiträge aus chinesischen Quellen zur Kenntnis der Türkvölker und Skythen Zentralasiens, Abhandlungen der Preussischen Akademie der Wissenschaft* (1904). See also Widengren (above, n. 1), pp. 1265 and 1267.

For many years Head's listing of rulers and chronology was more or less the standard for the field.[3] During the last few years, some numismatists have begun to focus on these problems and have tried to establish at least a relative chronology for the rulers. The suggested dating, depending on how the rulers are identified, varies by as much as a hundred years. The find now at the Getty furnishes much new material and a number of coin types that are not yet to be found in published sources. The collection is also important because of its composition, for it includes a group of coins from Elymais, an area that is relatively well documented historically and numismatically as a result of efforts by the French who have been carrying out excavations at Susa for years. The occurrence of coins from Elymais together with coins from the eastern part of the Parthian kingdom may therefore supply further information for establishing a chronology.

In 1978, A. M. Simonetta wrote with regret about the disappearance of a find of coins: "Some fifteen years ago a 'hoard' of coppers attributed to Sanabares was offered on sale in the U.S.A., but it has been dispersed without any record of it being kept and so a possibly invaluable piece of evidence has been lost."[4] It is possible that the coins in the Getty Museum are this very hoard of coppers.

[3] *HN*, pp. 818–22, cf. Debevoise writing 27 years later with almost no modification.

[4] Simonetta 1978, p. 161.

CATALOGUE

The coins in this find are uniform in both metal and type. The weight varies as a rule between 3.5 and 4 g, indicating that they were to be regarded as drachms — the Attic drachm weighed 4.1 g. Drachms, however, were usually of silver in the Greek, Roman, and (for the most part) Parthian periods. Since copper has replaced silver here without exception, it suggests that the coins were struck at a time when silver was not available for coinage.

The coins in the find, with the exception of those from Elymais, are all of the common Parthian type with the king in profile left on the obverse and an archer seated right on the reverse. The latter is always holding his bow in front of him in full side view. This motif, drawn from hellenistic prototypes, is found on the coins of the kingdom's founder, Arsaces I, the leader of the Parnian invaders from the north and the man for whom the ruling family of the Arsacids is named. He founded his kingdom a little after the middle of the third century B.C.[5] and, from that time on, the image of the seated archer was used again and again by the Parthian rulers, evidently as a conscious reference to the founder of the kingdom. On silver coins, which are usually of better quality than the often coarsely struck copper coins, the archer is dressed in long trousers and a cloak-like wrap similar to a Greek chlamys. He is also wearing a head covering, a bashlyk, typical of nomads in the Persian area of influence. In contrast, there is no suggestion of attire on the copper coins and only on the more carefully

[5] Debevoise, ca. 250 B.C.; Colledge, 247 B.C.; A. D. H. Bivar, "The Political History of Iran under the Arsacids," *CHI* 3, 1, p. 28 (citing J. Wolski, "The Decline of the Iranian Empire of the Seleucids and the Parthian Beginnings," *Berytus* 12 [1956–57], pp. 222–38) states "that Arsaces established his independent rule in ... 238 B.C."

struck coins in the main group of this find can we distinguish cap-like head coverings. On the earliest of the Arsacid coins, the archer is sitting on a stool, probably a folding camp stool like those common among nomads. From the time of Mithradates I (ca. 171 B.C.) the archer is often represented sitting on an omphalos, surely the influence of the Seleucid Apollo.[6] Under Mithradates II (ca. 124/3) the archer is seated on a throne, a feature that is retained from that time on. The backrest of this throne can sometimes be seen on the copper coins in this find, but in most cases a simple seat is suggested rather coarsely by one vertical and two horizontal strokes.

It has been assumed since the time of Gardner that the Greek letters and monograms on the reverse below the bow indicate the mint. Gardner was able to identify only a few mints, as was Newell.[7] Recently Sellwood has attempted to match over 30 combinations of letters and symbols with a dozen different mints.[8] Over one-quarter of the coins in the hoard have the symbol Π which, according to Sellwood, is Margiana (Merv). Nearly one-half of the coins, most of the large group 12 coins, come from a mint identified below as ♠, or Abarshahr (Nishapur).[9] Quite a few coins bear the symbols ⚶ and, following Sellwood, come from Aria (Herat). Only a few bear a T or ᛡ and are therefore from Traxiana (which this author believes is modern Damghan, not Meshad).[10] Thus, all of these coins were minted in the eastern part of the Parthian kingdom and, more particularly, in the northern part of that area. In addition to these eastern coins, there is a small group of Elymaean coins from the extreme southwest.

[6] Sellwood, p. 11.

[7] Gardner *BMC*, p. 24, and E. T. Newell, "The Coinage of the Parthians," A. U. Pope, ed., *A Survey of Persian Art* (London, 1938), vol. 1, p. 477.

[8] Sellwood, pp. 13 and 15.

[9] See the discussion below, pp. 32–34.

[10] The site of Traxiana has not yet been convincingly located. It has been suggested that it be identified with Meshad which is very close to Abarshahr (Nishapur), inconveniently close for two mints. Damghan, some 375 miles to the southwest, seems a more likely place for a mint. It had been occupied since prehistoric times and was the capital of the ancient province of Qumis.

NORTHEASTERN MINTS

Obv. Head of ruler 1.
Rev. Archer seated r., holding bow.

Phraates IV (ca. 38–2 B.C.) / Phraataces (ca. 2 B.C.–A.D. 4)

Group 1, Plate 1

> Obv. pointed beard, triangle-shaped hair style. To upper r. and
> 1. (?) traces of Nike crowning.
> Rev. legends probably in two rows around flan. Beneath bow
> 1–5 Π, 6–7 Τ.
> Extremely worn.

Margiana

1. Sellwood 54.9, "Phraates IV," 3.74 ↑
2. 2.99 ↑
3. Sellwood 56.13, as Mitchner, *Indo-Parthians* 645, "Phraataces,"
 3.48 ↑
4. 3.90 ↗
5. 4.15 ↗

Traxiana

6. Sellwood 56.13, "Phraataces," 4.02 ↗
7. 3.70 ↗

Phraataces (ca. 2 B.C.–A.D. 4)

Group 2, Plate 1

> Obv. probably pointed beard, hair stands out at back, triangular
> form. To upper r. and 1. Nike crowning.
> Rev. archer has short trunk, very short calves. Legends
> evidently in two rows, no longer legible. Beneath bow, Π.
> Extremely worn. Sellwood 57.14, "Phraataces."

Margiana

 8. 3.89 ↗
 9. 3.86 ↗
10. 3.43 ↗
11. 3.94 ↗

<div align="center">Artabanus II (ca. 10–38)</div>

Group 3, Plate 1

> Obv. to upper r. and l. Nike crowning.
> Rev. archer has very short trunk. Above CIΛE; below CIΛE; r. bottom to top APTA. Beneath bow, Π.
> Extremely worn. Sellwood 62.12, "Artabanus II"; Dobbins, p. 139, 7, "Vardanes I or Gotarzes II"; Mitchiner, *Indo-Parthians* 1157 (left and center), "uncertain ruler."

Margiana

12. 3.52 ↑
13. 3.93 ↗
14. 3.78 ↗
15. 3.75 ↗
16. 3.87 ↗
17. 3.70 ↑

Group 4, Plate 1

> Obv. diadem with large double bow at back of head; crescent moon and star in front of forehead.
> Rev. archer very small. Legends illegible. Beneath bow, Π.
> Extremely worn. Sellwood 63.16, "Artabanus II"; Mitchiner, *Indo-Parthians* 1160 (second row center) "some West Afghan local issues based on Parthian, rather than Indo-Parthian, prototypes."

Margiana

18. 4.28 ↑
19. 3.98 ↑

20. 3.87 ↑
21. 3.43 ↑

Vardanes I (ca. 40–45)

Group 5, Plate 2

> Obv. crescent moon and star of six dots in front of forehead, dotted border.
>
> Rev. circular legend, illegible. Beneath bow ᚱ.
>
> Very worn. Wroth *BMC*, p. 167, 55, pl. 27, 7, "Gotarzes"; Dobbins, p. 139, 8/G, "Gotarzes II (though this is not certain)"; Mitchiner, *Indo-Parthians* 1154 (bottom row, center) "Sanabares II."

Margiana (or Aria?)

22. 4.09 ↑
23. 3.57 ↑
24. 3.85 ↑
25. 3.89 ↗
26. 3.73 ↗
27. 3.74 ↗
28. 3.86 ↗
29. 3.89 ↗
30. 3.45 ↗

Vologases III (ca. 105–47)

Group 6, Plate 2

> Obv. double diadem; hair in three layers, lightly waved strands; moustache ends turn downward; short diagonal strokes depict beard on cheeks, slightly wavy beard on chin. Dot forms lower lip. Earring. Dotted border.
>
> Rev. l. thigh visible above r. Below traces of legend [BA]CIΛC. To l. Vologases symbol ℈. Beneath bow Π.
>
> Sellwood 78.12.

Margiana

31. 3.46 ↗
32. Obv. in front of forehead crescent moon cuts through border. 3.84 ↖
33. 3.76 ↖
34. 4.03 ↖
35. Rev. round cap on archer. Above bow CIΛ. 3.92 ↖
36. Obv. smaller head, long beard, strands of hair coarse. Double line around neck. 3.47 ↑
37. Obv. small head, cheeks clean, pointed chin beard. Rev. l. and above ABACIΛ. No Vologases symbol. 3.55 ↑

Sanabares II (ca. second quarter of the second century)

Group 7, Plates 2 and 3

Obv. double diadem with bow at back, hanging tie curves; hair divided into three loose, more or less horizontal waves; moustache arches downward; chin beard relatively straight at bottom. In front of beard dot indicates lower lip. Ring around neck. Crescent moon in front of forehead; above, star (not always preserved). Dotted border.

Rev. one thigh higher; knees depicted as round turning points, one higher; l. foot behind r. so gap between calves. From top l. CANABAPHC BACIΛE. Beneath large bow, large Π. Gardner *BMC*, p. 113, 2, pl. 23, 11; Simonetta 1957, pl. 4, 16; Simonetta 1978, figs. 2, 21; Mitchiner, *Indo-Parthians*, 1154 (top row, left).

Margiana

38. 3.28 ↑
39. 3.38 ↑
40. 3.82 ↗
41. 3.71 ↗
42. 3.46 ↖
43. 3.20 ↖
44. 4.06 ↑
45. 4.01 ↑

46. 3.62 ↑
47. 3.94 ↑
48. 2.83 ↑

Group 8, Plate 3

 Obv. double diadem, large triangular bow at back, wavy tie; hair in three almost parallel waves; moustache turns down, then up; narrow cheek beard. Large almond-shaped eye. Traces of crescent moon and star in front of forehead on some specimens.

 Rev. archer probably bearded, with round cap. Thin line indicates l. thigh above r. Traces of circular inscription **CANABAPHC BACIΛE[Y]**. Beneath bow, large **Π**.

 D. Sellwood, "The Ancient Near East," *Coins: An Illustrated Survey, 650 B.C. to the Present Day*, ed. M. J. Price (1980), p. 253, 1198 (which is not, however, identical; there are, among other things, four layers to the hair). Also related are: Dobbins, p. 139, fig. 4/S; Mitchiner, *Indo-Parthians*, 1154 (top row, center); Simonetta 1978, figs. 2 and 22.

Margiana

49. 3.80 ↗
50. Obv. square beard, double ring around neck. Rev. alternating series of angles at bottom, to l. Gondophares symbol ⴧ. 3.50 ↑
51. Obv. hair in four layers. Rev. Gondophares symbol, ⴧ. Mitchiner, *Indo-Parthians*, 1158 (top row, right). 3.60 ↖
52. Obv. Crescent moon and star in front of the forehead. 3.73 ↖
53. Obv. crescent moon in front of forehead, cutting through dotted border. 4.38 ↑
54. Rev. legend complete. Petrowicz, pl. 19, 7; Göbl 2, 2286; Mitchiner, *Ancient World*, 2647; Mitchiner, *Indo-Parthians*, 1154 (second row, left and right) and 1158 (top row, left). 3.44 ↑
55. Obv. hair in three layers, chin beard ends irregularly. Crescent moon and star in front of forehead. Rev. traces of legend on r. edge, very coarse, corrupted. 3.80 ↑

56. Obv. short hair in three loose layers. Rev. l. legend complete. 3.83 ↑

Group 9, Plate 3

> Obv. double diadem with rounded bow at back of very narrow head; hair in four layers with loose waves; curved moustache; lower part of cheek has beard of three downward strands, ending in straight line. Dotted border.
> Rev. beneath feet of archer, series of alternating angles. Above small bow, legend partially preserved. Beneath bow, Π.

Margiana

57. 3.12 ↖
58. 3.57 ↖
59. Obv. hair probably only in three layers. Top of head somewhat wide. Rev. very small bow. 3.63 ↗
60. 3.43 ↖
61. 3.71 ↖
62. Obv. crescent moon in front of forehead. Rev. archer's cap extends upward over forehead and stands out in back. 3.90 ↑
63. Rev. large bow. 3.41 ↖
64. Obv. upper part of head very narrow. Rev. archer's headdress looks like ski cap. Letter above small bow looks like Pahlavi alef. 3.49 ↑
65. Obv. large head partially off flan. Rev. very coarse. 3.54 ↑
66. Obv. very coarse; four-layer hairstyle, upper part of head wider with double diadem. Beard hangs down from lower part of the cheek. Crescent moon and star in front of forehead. Rev. illegible. 3.59 ↖

Group 10, Plate 4

> Obv. double diadem with round bow at back of head; three-layer hairstyle of coarse strands; curved moustache; lower part of cheek has beard consisting of three lines that run diagonally to bottom right, with square-cut chin beard. Ring around neck; below, bow-shaped neckline of garment. Dotted border.

Rev. l. thigh visible above r., l. calf disproportionately long. Legend illegible; following E at l. traces of Y. Below, series of alternating angles. Beneath bow, Π.

Margiana

67. 4.27 ↖
68. 3.97 ↑
69. 3.43 ↖
70. 3.87 ↖
71. 3.29 ↑
72. 3.69 ↖
73. 3.87 ↖
74. 3.54 ↖
75. 3.33 ↖
76. 4.09 ↖
77. 3.76 ↖

Sanabares II (ca. second quarter of the second century) or his successor

Group 11, Plates 4–6

Obv. very coarse, 78–87; extremely coarse, 88–128. Double diadem, hair in three loose layers in coarse strands; short, curved moustache; cheek beard represented by three strokes running downward diagonally to r., with straight-cut chin beard. Crescent moon in front of forehead? Ring or neckline showing on neck.

Rev. coarse, 78–87; extremely coarse, 88–128. Individual parts of archer's body exhibit rounded forms. Legend illegible. Beneath strongly curved bow ᛡ.

For 88–128, Simonetta 1957, pl. 4, 17; Mitchiner, *Indo-Parthians*, 1154 (top row, right); Dobbins, p. 39, 5; Mitchiner, *Indo-Parthians*, 1158 (top row, third from left).

Aria

78. 3.63 ↖
79. Obv. large eye. 3.62 ↑

80. 3.33 ↖

81. 3.90 ↗

82. 3.87 ↗

83. 4.09 ↖

84. Obv. hair in loose bunch. 3.64 ↖

85. Obv. hair in loose bunch. Rev. Vologases (?) symbol to l. 3.49 ↗

86. 3.67 ↖

87. Obv. has thick, uneven lump of copper on upper r. Rev. depression in upper part. 3.27 ↖

88. 3.53 ↗

89. 3.67 ↑

90. 3.80 ↑

91. 3.85 ↑

92. Rev. dots in open space of bow. 3.75 ↑

93. 3.69 ↑

94. 3.11 ↑

95. Rev. as 92. 3.65 ↑

96. Rev. as 92. 3.71 ↑

97. Rev. as 92. 3.67 ↖

98. Rev. as 92. 3.66 ↖

99. Rev. as 92. 3.55 ↗

100. Rev. as 92. 3.48 ↗

101. Rev. as 92. 3.40 ↗

102. 3.58 ↑

103. 3.52 ↖

104. Obv. strands of hair cursorily indicated, pointed beard. 3.84 ↖

105. 3.74 ↗

106. 3.79 ↖

107. Obv. very small knot of hair. 3.21 ↑

108. 3.54 ↗

109. 3.78 ↑

110. 3.55 ↗

111. 3.66 ↑

112. 3.67 ↖

113. 3.76 ↖

114. 3.17 ↑

115. 3.54 ↖

116. 3.57 ↗
117. 3.36 ↖
118. 3.49 ↗
119. 3.69 ↖
120. 3.33 ↗
121. Obv. one-quarter of head off flan. 3.62 ↖
122. Obv. one-half of head off flan. 3.48 ↖
123. Obv. head portrayed incompletely. 3.14 ↑
124. 3.63 ↖
125. 3.93 ↑
126. 3.71 ↖
127. 3.52 ↖
128. 3.41 ↑

Ruler of Abarshahr (ca. second half or last quarter of the second century)

Group 12, Plates 6–11

> Simonetta 1957, pl. 4, 18 and 20, "Sanabares II"; Dobbins, p. 39,
> 6, "Sanabares or, more likely, his immediate successor";
> Mitchiner, *Indo-Parthians*, 1155 (second and third from left in
> top row), "Sanabares II (probably)," 1158 (first and last in
> middle row), "uncertain ruler"; Simonetta 1978, fig. 2, 24 and 25.

Subgroup A

Obv. double diadem of dots, triangular bow at back of head with
dots at the ends; hair in loose bunch made up of small curls;
curved moustache; cheek beard indicated by three coarse
strands running downward to r.; chin beard formed by four
slightly waved strands. Crescent moon and star in front of
forehead and cutting through dotted border. Earring and
elaborate necklace.

Rev. cap extends above forehead and behind neck. Figure
booted, beneath feet ΛΔ upside down. Counterclockwise
legend begins above bow: 𐭀𐭁𐭋𐭔𐭕𐭓 = ABLŠTR, Abarshahr.
Beneath very small bow, 𐭀

Abarshahr

129. 3.62 ↖
130. 4.46 ↗
131. 3.44 ↗
132. 3.70 ↗
133. 3.84 ↗
134. 3.94 ↗
135. 3.63 ↑
136. 3.83 ↑
137. 3.52 ↗
138. 3.87 ↗
139. 3.50 ↑
140. 3.46 ↑
141. 3.24 ↑
142. 3.15 ↗
143. 3.11 ↗
144. 3.42 ↗
145. 3.33 ↗
146. 3.29 ↗
147. 3.57 ↑
148. 3.24 ↗
149. 3.26 ↑
150. 3.65 ↑
151. 3.60 ↑
152. 3.42 ↑
153. 3.36 ↑
154. 3.80 ↑
155. 3.52 ↑
156. 3.09 ↑
157. 3.66 ↑
158. 3.38 ↖
159. 3.67 ↑
160. 3.66 ↑
161. 3.57 ↖
162. 3.83 ↗
163. 3.78 ↑

164. 3.22 ↑
165. 3.59 ↑
166. 3.58 ↑
167. 3.62 ↗
168. 3.37 ↗
169. 3.41 ↑
170. 3.52 ↗
171. 3.52 ↑
172. 3.54 ↓
173. 3.41 ↖
174. 3.71 ↑
175. 3.28 ↑
176. 4.06 ↑
177. 3.61 ↑
178. 3.82 ↑
179. 3.59 ↑
180. 3.56 ↑
181. 3.45 ↑
182. 3.20 ↑
183. 3.69 ↗
184. 3.94 ↑

Subgroup B

Obv. portrait small, hair not as abundant so looks elongated.

Abarshahr

185. 3.73 ↗
186. 3.65 ↗
187. 3.68 ↑
188. 3.91 ↑
189. 3.80 ↑
190. 3.27 ↗
191. 3.49 ↗
192. 3.55 ↗
193. 3.84 ↗
194. 3.46 ↗
195. 3.96 ↑

Subgroup C

Obv. coarser. Very small head; curls replaced by waves. Crescent
moon above dotted border.

Rev. coarser. Archer wears round cap; calves shown nearly
frontal. Letters of legend widely spaced.

Abarshahr

196. 4.19 ↖
197. 3.96 ↖
198. 3.58 ↖
199. 3.80 ↖
200. Rev. cap with three dot-like decorations. 3.55 ↑
201. Obv. hair at back divided into pairs of curved lines. Rev. l. thigh
very short, l. calf long and bent back. 3.30 ↑
202. 3.63 ↗
203. 3.10 ↑
204. 3.81 ↖
205. Rev. archer wears long trousers. 3.70 ↖
206. 3.80 ↖
207. 3.33 ↖
208. 3.27 ↖
209. 3.77 ↖

Subgroup D

Obv. hair in loose waves. Earring split at bottom. Crescent
moon and star cut through dotted border.

Rev. archer's cap extended at neck. Last letters of legend widely
spaced. Very small bow.

Abarshahr

210. 3.85 ↗
211. 3.75 ↖
212. 3.77 ↑

Subgroup E

Obv. top of head narrow; hair is pear-shaped, slight waves; moustache turned up at end; squarely trimmed chin beard. Double neckline.

Rev. archer wears cap with long extensions above forehead and behind neck. Last two letters of legend very widely spaced. Beneath very small bow, ♠.

Abarshahr

213. 3.33 ↑
214. 3.53 ↗
215. 3.82 ↑
216. 3.66 ↑
217. 4.06 ↗
218. 3.09 ↗
219. 3.66 ↖
220. 3.76 ↑
221. 3.75 ↗
222. 3.67 ↗
223. 3.66 ↗
224. 3.31 ↑
225. 3.67 ↗
226. 3.66 ↖
227. Rev. archer appears to be wearing trousers. 3.67 ↖
228. Double struck. 3.48 ↖
229. 3.64 ↗
230. 3.64 ↖
231. 3.59 ↖
232. 3.51 ↖
233. 3.55 ↗
234. 3.53 ↑
235. 3.49 ↗
236. 3.31 ↖
237. 3.47 ↖
238. 3.59 ↗

239. 2.93 ↗
240. 3.44 ↑
241. 3.35 ↖
242. Obv. hair appears to be more stepped. 3.50 ↑

Subgroup F

Obv. portrait very similar to subgroup A, but curlier hair. No crescent moon or star.

Rev. Archer wearing short, round cap. Last letters of legend widely spaced. Beneath bow ꓱ.

Traxiana

243. 3.33 ↖
244. 3.77 ↖
245. 3.40 ↖
246. 3.66 ↖
247. 4.08 ↖

SOUTHWESTERN MINT: SUSA

Vardanes I (ca. 40–45)

Group 13, Plate 12

Obv. double diadem; hair hangs almost straight down; beard trimmed short. Small, drop-shaped form in front of forehead. Dotted border.

Rev. extremely poorly preserved.

Le Rider, pl. 20, 228–29, 231–33.

248. 3.23 ↑

Obv. head of ruler l. (249–61) or facing (262–66).
Rev. female figure.

Unknown ruler (ca. first quarter of second century)

Group 14, Plate 12

Subgroup A

Obv. very small face. High bunch of hair above head, gathered together in a stem-like form at head, heavy bunch of hair composed of bulging curls on neck; broad beard made up of thick, loose curls. Neckline visible. Traces of anchor behind head.

Rev. Athena, head r., in r. hand spear, in l. shield, r. foot on slight elevation. Dotted border.

Allotte de la Fuÿe, 184 and 186, "Vologases II ou III," pl. 14; Wroth *BMC*, p. 187, 73, "Volagases I," pl. 29, 8; Mitchiner, *Ancient World*, p. 126, 723, "Prince B, circa A.D. 200"; J. de Morgan, *Numismatique de la Perse antique*, vol. 3 of E. Babelon, ed., *Traité* (Paris, 1930), p. 484, "Prince β, entre 198 et 224 ap. J.-C.," pl. 39, 31–32.

249. 2.66 ↑

Orodes III (ca. second quarter of second century)

Subgroup B

Obv. double diadem; above, large bunch of curls (250) or bunch of hair (251–52); behind, several rows of curls (250) or another bunch (251–52); pointed beard. Round neckline. To l. Aramaic legend ‏Ⅎℵ 𐤌𐤋𐤊‎ WRWD MLK', King Orodes (250). Dotted border (250).

Rev. head of woman l., torso frontal, dotted hair curls, curved braid from top of head ends in separate strands. To l. Aramaic legend ‏ﺟﻮﻟﺞ‎ WLP'N, Ulfan (251), traces of legend (252).

Hill *BMC*, pp. 280–81, "Orodes III," pl. 42, 5–6; Allotte de la Fuÿe, 162–68; Allotte de la Fuÿe, "Les Monnaies de l'Elymaïde," *RN* 1919, p. 82, "Orodes III," pl. 2, 22–23; de Morgan, pp. 481–82, "Orodes IV," "vers 193 ou 198 ap. J.-C." pl. 39, 14–16; "Monnaies des rois d'Elymaïde," 186, pl. 2.

250. 3.09 ↑
251. 2.86 ↗
252. 2.96 ↗

Abar-Bāsī (ca. 150–65)

Subgroup C

Obv. above double diadem, row of curls; above forehead, bunch of curls; large bunch of hair at back (253), small bunch (254–56), dotted bunch (257); dotted beard; chin beard in two rows of dots. To r. anchor (254–57), above crescent moon and star (257).

Rev. Artemis standing frontal, head r.; rayed crown (255–56). In l. hand bow, r. taking arrow from quiver. Dotted border (253–55).

Allotte de la Fuÿe, 179–82, "Orodes IV," pl. 14; Allotte de la Fuÿe, Les Monnaies de l'Elymaïde," *RN* 1919, p. 84, 32–33, "Y," pl. 2; Hill *BMC*, pp. 284–86, "uncertain kings," Bi, 14–16, pl. 42; de Morgan, pp. 483–84, "prince α," 26, 28, pl. 39; "Monnaies des rois d'Elymaïde," 190, pl. 2; Le Rider, pl. 74, 7–8.

253. 2.53 ↗
254. 2.15 ↗
255. 2.31 ↑
256. 2.31 ↗
257. 2.94 ↑

Orodes IV (ca. 165–end of second century A.D.)

Subgroup D

Obv. double diadem, bow at back of head with two ties hanging; high knot of hair on top of head, none on back of neck; dotted chin and cheek beard. Aramaic inscription ⌐3IΛ3I⅂Il, **WRWD MLK'** (258). Dotted border.

Rev. head of Artemis l.; crown of double row of beads, base of crown curls up over forehead and at back; bow and two ties at back. Earring with bead. Neck ring and drapery. Anchor behind head. Dotted border.

Allotte de la Fuÿe 171, "Orodes IV," pl. 14; Allotte de la Fuÿe, "Les Monnaies de l'Elymaïde," *RN* 1919, p. 83, a, pl. 2, 28, and p. 84, b, "Orodes IV," pl. 2, 29; Hill *BMC*, p. 282, l., Bg; de Morgan, p. 483, 57, "Orodes V," pl. 39, 21; "Monnaies des rois d'Elymaïde," 187–88, pl. 2; Le Rider, pl. 74, 4; Göbl 2, p. 204, 2077, "Orodes IV," pl. 101; Mitchiner, *Ancient World*, p. 125, 720, "Orodes VI, late 2nd. century A.D."

258. 2.68 ↗
259. 1.95 ↗

Subgroup E

Obv. double diadem with heart-shaped bow, two ties hanging; one row of curls on head, no hair at back; long beard of two rows of curls. Drapery visible.

Rev. Artemis standing frontal, head r., l. hand with bow slightly lowered, r. taking arrow from quiver. Dotted border.

Allotte de la Fuÿe 176 "Orodes IV," pl. 14; Allotte de la Fuÿe, "Les Monnaies de l'Elymaïde," *RN* 1919, pp. 83–84, 180, "Orodes IV," Y, pl. 2, 32; de Morgan, pp. 483–84, 58, "Prince α," pl. 39, 27; Le Rider, pl. 74, 9.

260. 2.54 ↗
261. 2.50 ↗

Unknown Ruler (ca. 200)

Subgroup F

Obv. simple diadem, row of curls and bunch of hair above, bunches of curls to r. and l. beneath; ties visible beneath r. bunch; moustache curves slightly up; chin beard of two rows of curls. Dotted border.

Rev. head of Artemis l., covered with small curls, rayed crown, bow at back of neck, two ties. Ring around neck, below beads (or drapery). Behind head anchor.

Hill *BMC*, p. 280, 2, "Orodes III," pl. 42, 2; Allotte de la Fuÿe, "Les Monnaies de l'Elymaïde," *RN* 1919, p. 83, b, pl. 2, 26; Le Rider, pl. 74, 5; Mitchiner, *Ancient World*, p. 126, "Prince C, early 3rd century A.D."

262. 2.56 ↗
263. Cf. Hill *BMC*, pl. 42, 3–4; Le Rider, pl. 2, 5. 2.87 ↗
264. 2.34 ↗
265. Cf. Allotte de la Fuÿe, "Les Monnaies de l'Elymaïde," *RN* 1919, pp. 82–83, "Orodes III," "avec un croissant et un astre," pl. 2, 27, but crescent and star not visible. 2.72 ↗
266. 2.16 ↗

ANALYSIS OF GROUPS

In analyzing the individual groups, we will begin with those coins that can be classified most readily with coins already known in the literature and which are therefore most easily identified. The other coins in the find will then be grouped around them, the state of preservation offering some clues in this regard. The results of this analysis have already been taken into account in the organization of the catalogue so that the coins appear there in their assigned chronological order. In the analysis below, however, the numbering is not consecutive from group 1 to 14 but skips back and forth. Following the group identification, the catalogue numbers of the relevant coins are given.

Group 7, 38–48

Several coins of Sanabares II, ca. A.D. 125, are known. His name, however, is not readily explicable. W. B. Henning sees in the first part the old Parnic word *sān-* meaning "enemy," and reads the second part as *bar-* in the sense of "lead away."[11] Sellwood 93.3 is a coin of Sanabares with an Aramaic legend which he reads as *š'n*; unfortunately, he reproduces only a drawing and not a photograph of the coin. By way of contrast, the Aramaic letters on silver coins illustrated by Simonetta[12] are clearly *s'*.[13]

[11] *Handbuch der Orientalistik*, vol. 1, pt. 4 (1958), p. 41, n. 1.

[12] Simonetta 1957, pl. 4, 10–15.

[13] These two letters can also be seen behind the portrait on Simonetta's 9. The coin seems therefore to be an issue of Sanabares. The problem of whether this is the same Sanabares or another ruler of the same name will be discussed in relation to the historical importance of this find.

The most familiar Sanabares copper coin type is represented by an example in the British Museum.[14] The obverse shows the head of the bearded ruler in profile left. He is wearing a double diadem that is tied in a bow at the back, one end pendant. His hair is divided into three horizontal waves, and in front of his forehead there is a crescent moon with a star. The portrait is outlined by an arched dotted border. The reverse depicts the Arsacid archer; beneath his bow there is a Π, believed to indicate the mint at Margiana. In a circle around the archer, beginning above his head, is an inscription ϹΛΝΛΒΛΡΗϹ ΒΛϹΙΛΕ. There are a number of coins of this type in the Getty hoard which are even less worn than the one at the British Museum, and the individual strands of hair that form the waves can still be distinguished (e.g. 38–39). It can also be seen that the king wore a torque around his neck. The inscription on the reverse is only incompletely preserved in all cases.

The obverses of 38–40 are very similar. The round eye is framed by a relatively straight upper lid and a slightly curved lower lid. Whether 38 and 39 had a crescent moon and star in front of the forehead is not clear. The lower part of the legend has been preserved on the reverse of 38 [ϹΛΝΛΒΛ]ΡΗϹ ΒΛ[ϹΙΛΕ]. On 39, the last two letters of the word ΒΑϹΙΛΕ are just recognizable behind the back of the archer. The next two coins are very similar. The star and crescent moon are preserved clearly on the obverse, as is the case with the following coins from this group. On 40, traces of the letters ΙΛΕ are visible on the reverse behind the archer's back; on 41 are Ϲ and ΘΑ, the retrograde letter indicative of deteriorating standards. Similarly on 42, where the final Ϲ and the word ΒΑϹΙΛΕ are otherwise quite legible on the reverse.

Of the remaining group 7 coins, 45 is worth noting for its well preserved obverse with the original fine lines of the portrait still recognizable. On 46 the individual strands of hair form waves that are deeply incised. On the obverse of 47 the bow in the ribbon of the diadem forms a triangle with rounded angles. This contrasts with the preceding examples where the bow was round, insofar as it was

[14] Gardner BMC, pl. 23, 11; Simonetta 1957, pl. 4, 16; Mitchiner, *Indo–Parthians*, 1154, top row, l.

preserved at all (40, 42, and 46). On the reverse of both 47 and 48 there are traces of the word BACIΛE on the left.

Group 8, 49–56

Another group representing a somewhat different type can also be assigned to Sanabares. On these coins, the waves of the individual layers of the hair are more pronounced in the back,[15] the bow of the diadem is triangular, the beard is trimmed squarely, and the large eye is framed by almond–shaped lids. The lines are coarser on the whole, a feature that is particularly noticeable in the legends on the reverse which are only partially legible. The beginning of the inscription on the reverse of 49 is the most clearly preserved : CANA. To the right, there are traces of a retrograde P.[16] What seems to be the end of the word BACIΛE appears on the left; there is an additional stroke behind the E that may continue at the top toward the left and the right and is perhaps, therefore, a coarsely executed Y like the one preserved on 54 and 55. This suggests the word ΒΑΣΙΛΕΩΣ, in which case the second sigma is missing, for the only sigma present forms the beginning of the name Sanabares.

The obverse of 50 is very similar to that of the preceding coin; the reverse is, however, coarser. Of the inscription there are only three alternating angles remaining, ΛVΛ beneath the feet of the archer and Π. At the archer's back there is a Gondophares symbol Ⴘ. The name of the sign comes from Gondophares I (first half of the first century A.D.) during whose reign it first appeared. It is presumably a symbol for sun and moon.[17]

An exact parallel for the reverse of the foregoing coin can be found in 51, although it is in part less well preserved. The obverse is comparable in layout and execution to 50, although the hair is divided into four layers. The same is true of 52 which has a crescent moon and a star in

[15] See Dobbins, p. 139, 4/S, and Mitchiner, *Indo-Parthians*, 1154, top row, center.
[16] This can be seen even more clearly on 54.
[17] Simonetta 1978, pp. 158 and 186. It is also to be found on coins of Sasan, Satavastra, and Sarpedanes; see D. W. MacDowall, "The Dynasty of the Later Indo-Parthians," *NC* 1965, p. 147.

front of the forehead; the reverse is also to be grouped with 50 and 51, although this coin is less well preserved. Traces of the series ΛVΛ are recognizable beneath the feet of the archer. Coin 53 also represents the type with the four-layer hair style and the square beard; the letters ΛNΛ are clearly recognizable at the top of the reverse. They are all on about the same level since the archer is executed in smaller scale. Jutting up into the open side of the Π is a point which might belong to the series of angles observed on 50–52 or might indicate a different mint, i.e., the one at Aria ᛝ.

Somewhere between groups 7 and 8 is 54; it is very finely worked so that it probably should be assigned to the earlier issues. The way the beard falls and the round bow of the diadem link it to group 7, but the hair is shown in four layers. The inscription on the reverse is preserved only at the back and beneath the feet of the archer; it is clearly formed but has a Y at the end as on 49 and 56. Comparable pieces are to be found in Petrowicz, pl. 19, 7 = Göbl 2, pl. 111, 2286, and in Mitchiner, *Indo-Parthians*, 1154, second row, r.

Also displaying characteristics of both groups is 55. The three-layer arrangement of the hair and the style of the beard are comparable to group 7 coins; the almond-shaped eye and the reverse, however, link it to the present group. Traces of the inscription on the reverse reveal a retrograde P; following the elongated H, there is a line instead of the expected C. The state of the inscription has thus already deteriorated considerably. The obverse is very similar to that of 56. On this latter coin, the left part of the reverse is preserved and clearly has a Y following the ΛE of BACIΛE (cf. 49). The final sigma is turned by 90° and is, therefore, clearly set off from the preceding letters, so is the first letter of the name Sanabares.

Group 9, 57–65 and 66

This group of coins closely resembles the preceding group but it was evidently struck later since the style is even coarser. The coins have the layered hair style typical of Sanabares, with three or four waves formed by slightly waved strands that lie lightly one upon the other. The bow of the diadem is rounded and a crescent moon is still recognizable in front of the foreheads in two examples, 63 and 64. The

traces of the reverse inscription have become even more obscure and the meaning is no longer clear. What little has been preserved on the left side behind the archer represents the version with Y following the word BACIΛE, but most of the latter is no longer legible. Indeed, only the E is completely preserved and in some cases (e.g., 65) it has taken on rather large dimensions. On 57, above the bow of the archer (represented in very small scale on most of this group) there is an N and, next to it, traces of a second letter. This seems rather to be a Δ than an A, however. Traces of another letter are to be found on the right between the bow and the mintmark Π. These traces could, therefore, represent the name Sanabares. Below the Π and beneath the feet of the archer and running upward toward the left, there is a series of angles in opposition, comparable to those on most of group 8.

Included here is coin 66 which probably represents another group although it exists as a unique example here. It is very coarsely worked. The obverse has the four-layer hair style and a crescent moon and a star can be recognized in front of the forehead. The reverse is very poorly preserved, but traces of the letters BAC are still recognizable at the bottom.

Group 10, 67–77

The coins of this group appear to belong to an even later period of issuance. The reverses correspond to those of the preceding group, which are already very poorly executed. The obverses are even more coarsely worked in comparison with those of the preceding group but have the typical three-layer hair style, usually in a shorter variation, and a clipped beard similar to that of group 8. The crescent and star are missing. The ruler is wearing a torque around his neck and, in many cases, the curved neckline of his gown can be seen beneath it. Only small details distinguish the different coins of this group.

Group 11, 78–128

Group 11 is even more coarsely worked than group 10. It was issued from a different mint, presumably Aria, since beneath the bow the

monogram Ⴘ is to be found. Included in this group are coins that have been published elsewhere.[18]

On the obverses, the hair style is in three layers, characteristic of Sanabares; it is clearly recognizable, for instance, on 78, 82, 83, 85, and 86. The three layers are common to all the coins of this group, but in general the hair is only coarsely depicted. There is no crescent moon or star.

The reverses of all the coins in this group are very coarsely engraved. The bow of the archer hangs down very low on some of them, for instance on 78–80, 94, 109, 115, and 124. In other cases, such as 96–101, the bow is decorated with two dots in the middle. The inscription is illegible, and has no clear relationship to the earlier ⅭⱯⲚⱯΒⱯΡΗⅭ ΒⱯⅭΙⱯΕ. Above the bow, in front of the head of the archer, there is in some cases a letter form similar to a Λ (90, 95, 100, 101, 108, 109, and 117). On some of the coins, there are traces of another letter between the Λ and the head of the archer which looks like a retrograde gamma, Ꮁ (83, 103, 106, 111, and 112; 116 [traces]). To the right of this angle, some of the coins have another letter. It is similar to a Π, but the horizontal line is tilted somewhat toward the bottom right (90, 95, 101 and 112; 117 and 119 [traces]). Sellwood believes that this is the Parthian letter S and that the angle at the left is an R.[19] On 109, this letter is further to the right and lower, and beneath it is a Λ. There are two such Λ's, one above the other at the right, on a number of coins (82, 83, 87, 89, 90, 95, 97–99, 104, 105, 115, and 117); however, there is only

[18] Simonetta 1957, pl. 4, 17.22; Dobbins, p. 139, 5; and Mitchiner, *Indo-Parthians*, 1154, top row, r.; 1158, top row, center.

[19] Sellwood interprets these as traces of the name Osroes. Coins of Sanabares II actually do have comparable features with those of Sellwood 85 (Osroes II), although the former is with diadem, the latter with tiara. Worth noting, however, are the coarseness of the execution, the unusually large eye in a small face, and the pointed beard indicated by a few lines coupled with a relatively straight moustache (cf. Sellwood's line drawing 85.2 and Plate 4, 90). The double ring representing the neckline is also comparable. In addition there is the inclination to include pellets on these coins: Sellwood 85.2 has a pellet above the bow on the reverse, for example, while the dots in the middle of the bow on some of the hoard coins are in keeping with this.

Alternatively, the two letters could also be read as TB and the following angle on the right perhaps as R, providing parts of the name Artabanus. This might indicate Artabanus IV (Sellwood 89), who also used Parthian legends.

one Λ on 78, 79, 94, 100, 101, 103, 110, 111, 113, 114, 116, and 119–23. It is not possible to decide in these cases whether there was originally a second Λ or whether there was only one; on 109, since there the ⊓ is drawn further down the side of the flan, there is room for only one Λ.

Insofar as it is preserved, the same group of letters appears on all of these coins beneath the feet of the archer at the left of the monogram of the mint. The series runs ΛΟΙ but, if it ever had any meaning, might have been intended to be read the other way around, that is, from the middle of the coin.

In only a few cases is anything preserved at the left, behind the back of the archer; again, the traces have no apparent meaning. Above the Λ beneath the feet and the seat of the archer, there is a sort of bracket (88, 90, 94, 102, 104, 107, 113–14, 117, 118); above this, some coins have a V (88, 90, 102, 104, 107, 112–14, 117, 118); above the V, a few coins have a Λ (88, 90, 104, 112, 114, 118). This series may represent the deformed remains of the Aramaic word MLK' or "king." Above this on 90 are traces of a further letter which could have been the last letter of the name of the king.

On some coins that belong to this group, there are other symbols to the left instead of the preceding series of signs. On 85 it is not clear whether it is the Vologases symbol ⚨ or the Gondophares symbol ⚨; 86 appears to bear the Vologases symbol as does 124.[20] The Gondophares symbol is clearly depicted on 125 and above it there are traces of additional letters. The letters of the legend are more clearly recognizable on 126: above the Gondophares symbol there is first the bracket known from other coins, however it is turned by 90°, and the beginning of another letter is visible. The mint symbol seems to be a simple ⊓ in this case and beneath it, somewhat to the left, there is another letter that is similar to a squarish ⱳ. According to Sellwood, this is a coin from Margiana; so there must have been a coarsely engraved set of coins issued from there as well. This assumption is supported by a further coin in this group, 127. The obverse is quite worn; one can still see that the reverse is based on a meaningful

[20] It is no longer possible to tell whether there was a Vologases symbol or a comparable symbol on 123. The similarity between this coin, 122, and Mitchiner, *Indo-Parthians* 1158, bottom row, l., make it seem likely that there was.

inscription, but it is no longer legible. It is difficult to classify another of the coins as well, 128. Since only the upper parts of the Π are preserved beneath the bow, the mint is not clearly identifiable. The letters ME and probably a Γ can be read above the archer, presumably the remains of the word MEΓAC. There is a Vologases symbol at the back of the archer. The obverse has no known parallels and cannot be more precisely identified because of the degree of wear. Worth noting, however, is the fact that the portrait is surrounded by a cord instead of by the usual dotted border.

Group 12, 129–247

This group of coins forms the largest part of the find and different stages of development can be identified within it. These coins are very closely related to examples that have been attributed to Pakores, and Mitchiner 1078, in particular, can be cited here for comparison.[21] The arrangement of the hair in a thick bunch at the side of the head is typical of the group, although the fullness of the curls varies from one subgroup to another: in some cases it is reduced to broad waves, especially in subgroups C and D. On the Pakores coin the double diadem ends in a triangular bow at the back, a feature that is also found on some of the Sanabares coins; it is present on all the coins of group 12. On the Pakores coin his head is shown left and in profile, the upper body is almost full front and is turned only very slightly toward the left. There is a double torque around his neck that is held together in the front by a square clasp, evidently decorated with pellets. This same ornament is found on all the coins of group 12 where the lower parts are still preserved on the individual issues (it is particularly clear on 147, 184, 185, 187, and 189 and is still recognizable on many others). The earring on the coins in this group is also given special treatment: it is a ring with a thick bead at the top (129, 135, 141, 144, 147, 153, 184, 185, 188, etc.). To what extent this detail is also to be found on the Pakores coins cannot be determined from the illustrations available in the literature. Behind the head on the Pakores coin there are traces of Parthian letters. Comparable traces are lacking on the coins of group

[21] See also Simonetta 1978, fig. 2, 9 = Dobbins, p. 139, 12/PA.

12 and, instead, there is usually a crescent moon and a star in front of the forehead, as is often found on Sanabares coins. On the hoard coins 129, 130, 132, 133, 143, 149, 210, and many others, they cut through the dotted border in all but a few instances.

In those cases where the surface is still relatively well preserved, the coins in group 12 give evidence of careful execution. Thus, on some examples it is possible to see that the double diadem was made up of rows of individual pellets (135, 143, 146, 149, 157, 163, etc.), and on almost all of them it is still apparent that the corners of the triangular bow of the diadem were decorated with pellets.

Careful workmanship is also evident on some reverses in that the ends and the corner points of the individual letters are decorated with a dot. On some especially well preserved examples, such decoration can be seen on the cap of the archer, the decoration itself varying on different coins (cf. 136, 167, 172, 188, 195, 213, 217, 234, and 242 with 198, 200, and 246). Not only the cap but other details of clothing are indicated on these coins which speaks for careful execution — normally the case only for silver coins. The edge of the boot is recognizable on all of them, for example, and above the ankle, the boot either gets wider at the top or is folded over (129, 130, 134, 141, 142, 150, 152, etc.). In one case (205), the folds of long trousers can be seen.

The inscription presents a special problem. No attempt has been made up to now to read it, and it has been described as "usually corrupt."[22] But the careful workmanship that is sometimes evident and the frequency with which the inscription is to be found give substance to the assumption that the legend had a meaning. The elements of the legend are always in the same order. It is noteworthy that certain parts of this inscription are found in the same place as on all the Sanabares coins from this find: the ш behind the back of the archer which originally formed part of the word **ΒΑΣΙΛΕ** and an N-like letter above the bow where on earlier Sanabares coins "Sana," the beginning of his name, was located. As the inscription deteriorated, a **Y** was often added following the ш at the end; at first, the **Y** on Sanabares' coins had a long foot, but this later disappeared. The letter above the ш that is on coins in group 12 is similar to this letter. Two

[22] Mitchiner, *Indo-Parthians*, p. 777.

further additions that regularly appear indicate that there was not only an attempt made to give a better appearance to an obscure, unreadable inscription, but that a new meaning was intended. One is an additional letter to the left and below the letter above the ɯ. Further, below the ɯ two angles have been added which often differ slightly from one another. They are usually depicted one inside the other, as on 129, 130, 134, and 135, but they can also follow one another, as on 196, 201, and 202. Even if it is possible to see in one of them a turned Λ from the original word BAΣIΛE, it is not possible to explain the second angle in the same manner. This seems to speak more for the fact that letters which had deteriorated to the point of illegibility were given a new meaning, for which it was necessary to leave out superfluous parts and add new ones.

From those coins on which the right side of the reverse is still preserved (131, 151, 162, 165, 168–73, 177, etc.), we can see that no further inscription was planned next to the bow and the symbol for the mint. Above the bow, which is as a rule very small, there is a letter that looks like an elongated N, the right vertical stroke of which is very slightly curved (155, 172, 177, 217–19, 230, and many others on which only part of the letter is preserved). In the course of the different issues there is a certain deterioration to be noticed, and the letter sometimes appears to have been divided into two parts (e.g., 198 and 200). The main part of the inscription is located on the left side at the back of the archer. It is always the same and there are only very slight variations in detail. Beneath the feet of the archer and below the symbol of the mint, there is a series of signs to which we will return below.

Thus, the only unchanging series of signs on all the coins in group 12 is the one at the back of the archer and above his bow. There are parallels for the form of the letters in Aramaic script and its derivative, Parthian, both of which are read from right to left. Since no inscription was intended on the right side of the coin, it must have begun above the bow and run from there to the left, behind the back of the archer. Thus, we can establish an unchanging series, ꟊɯɾᴊɴ, RTŠLBA. Transposed, this indicates ABLŠTR, Abarshahr.[23]

[23] Another possibility would be to read the penultimate letter as a G; the word would then read abaršagr. The šgr is the Pahlavi šgl as transmitted in Manichaen

This word is not unknown. For instance, the religious founder Mani sent his pupil Mār Ammō to Abarshahr[24] and Merv since Mār Ammō knew Parthian (pahlawānig). The land of Abarshahr is also mentioned in the inscription of the Sasanian King Shapur I on the Ka'ba-yi Zardusht at Naqsh-i Rustam near Persepolis.[25] In line 55 there is mention of a ruler among those who lived under King Ardashir who is from 'Aβϱηναχ (Greek); '[pl]ynk (Middle Persian); 'prynk (Parthian).[26] M. Sprengling has interpreted this as the land of the Aparnians (Aparnia)[27] as has J. Markwart.[28] W. Eilers combines two of the possible interpretations of "Apar-šahr": 1) "Oberland, Hochland," and 2) "Land der Aparner," and describes the Aparnians as highlanders.[29] Furthermore, al-Tabari, an Arab historian of the early tenth century, reports that Ardashir, the founder of the Sasanian kingdom, undertook a campaign in the east, to Abarshahr, Merv, Balkh, and Khwarezm, to the far-lying borders of Khorasan and he returned to Merv from there.[30] All of these references make it clear that

writings, that is, neo-Persian šēr or "lion," a frequent component of names, as in the name Ardashir. This would then represent the throne name of the ruler in this area, the "lion of the highlands" or the "lion of the Aparnians" as he would have called himself; here there is a parallel with the founder of the Arsacid kingdom who was the leader of the Dahaean Parnians.

[24] W. B. Henning, *Handbuch der Orientalistik*, vol. 1, pt. 4 (1958), p. 94. In the Sogdian version cited there it is written 'βrš'r.

[25] This is a trilingual inscription. The Middle Persian portion was discovered before the Parthian and Greek portions were and was initially published by W. B. Henning, "The Great Inscription of Šāpūr I," *BSOAS* 9 (1937–39), pp. 823–49. For middle Persian 'prštr-y and Parthian 'prhštr, see Henning, *BSOAS* 12 (1947), p. 53, and 14 (1952), p. 512, n. 6. A. Maricq, "Res Gestae Divi Saporis," *Syria* 35 (1958), pp. 295–360, tried to resolve some of the disparities in the earlier translations.

[26] Maricq, p. 323. M. Back, "Die sassanidischen Staatsinschriften," *Acta Iranica* 8 (1978), p. 349.

[27] "Shahpuhr I, the Great, on the Kaabah of Zoroaster (KZ)," *American Journal of Semitic Languages and Literatures* 57 (1940), p. 399.

[28] "A Catalogue of the Provincial Capitals of Ērānshahr," *Analecta Orientalia* 3 (1931), p. 52.

[29] "Der Name Demawend," *Archiv Orientální* 22 (1954), p. 373.

[30] Theodor Noeldeke, trans., *Geschichte der Perser and Araber zur Zeit der Sasaniden* (Leyden, 1879), p. 17.

Abarshahr must lie in the area from which the coins in the Getty Museum collection came. The capital of a province often had the same name as the province itself (e.g., Margiana, Aria). This would also have been the case with Abarshahr. There was a mint there during the time of the Sasanians, and many coins from it are known. In Pahlavi inscriptions from this later period, the word is usually written 'prhštr or abbreviated to **APR** or **AP**, sometimes even **AB**. The spelling **ABL** is used on the coins in group 12, thus giving preference to the spelling with **B**; this can be attributed primarily to the fact that, as discussed above, parts of an earlier inscription were reused. In addition, the monogram ♠, located beneath the archer's bow, also apparently refers to the mint at Abarshahr.[31]

It is clear, therefore, that the coins in group 12 are on the one hand closely related to a group that can be attributed to Pakores and on the other that they exhibit many details found on the coins of Sanabares. Elements of the Greek legend which had completely deteriorated and could no longer be read were altered and given new meaning — they were changed to Parthian letters and formed complete words. As far as their chronological classification is concerned, the coins in this group must follow those of Pakores' and Sanabares' early issues. Whether they were struck during the reign of Sanabares or not is unclear. Perhaps they are rather to be attributed to one of Sanabares' successors in the latter half of the second century A.D., who took some trouble to see that the coins of his predecessor, which had become barbarized in the course of time, were replaced by coins of a higher quality, and who consciously drew upon a group of coins issued by Pakores in doing so.

Subgroup A, 129–84

The coins in group 12 are all very similar, and there are only slight distinctions between the different issues. In particular, the hair style undergoes some change in the course of time. From underneath the

[31] The attribution of Sellwood (p. 13), who sees in this the symbol for Mithradatkart, the citadel of Nisa, must be revised accordingly. The earliest coin from Abarshahr, with the letters **AΠA**, is one of Phraates II, Mitchiner, *Ancient World*, p. 110, 499.

diadem emerge four waved strands of hair that end in a relatively round knot of small curls. The beard on the chin is formed of four slightly waved strands; above it, there is a moustache that curves downward. Three strands indicate the beard on the cheeks; on coins of one variant, this part of the beard is made up of four strands (131, 181, 183, and 184).

The reverse on all these coins bears a clear impression of the legend discussed above. Only 152 varies from this common pattern: the L is positioned so low that it is practically on a line with the Š. The archer's bow is very small. The symbol for the mint, insofar as it is still decipherable, is ♠, Abarshahr. Sellwood regards the small o beneath the symbol as part of the sign for the mint;[32] but it appears rather to be part of the series of letters that follow to the left of the mint symbol. This latter interpretation is supported by the fact that the o is missing on other coins that are very similar in design (subgroup E), or it is replaced by another letter (subgroup F). On the A coins there are two signs to the left of the o; they look like Greek letters that are to be read from the middle of the coin, Δ and Λ. These two symbols could be interpreted as a number, 34, although it is not clear to what this number would then refer.

Subgroup B, 185–95

Another variant is very carefully executed. The reverse corresponds for the most part to the coins examined so far, but it is somewhat coarser. The series of signs beneath the feet of the archer corresponds to that in the preceding subgroup. The portraits on the obverse are smaller and the hair is not quite as full, thus giving the impression of being somewhat elongated. One coin, 195, is particularly coarse in workmanship and the only sign in front of the forehead is a crescent moon which cuts through the dotted border. This is in contrast to the other coins in this group which also have a star. The hair is only coarsely detailed.

[32] Sellwood, p. 13.

Subgroup C, 196–209

The tendency toward coarser execution grows stronger in succeeding issues. The depiction of individual curls in the hair gives way to broad waves that are somewhat fuller at the bottom. On a number of coins (201–7), the hair is divided into several pairs of curved lines toward the left and the right from the center. The workmanship of the reverse is very coarse. Insofar as his headgear is recognizable at all, the archer is now wearing a short round cap without the top piece above the forehead or the piece down the back of the neck, as is commonly found on the other coins of group 12. The main difference in the legend is that the last two letters are no longer placed one inside the other but are consecutive. The series of symbols beneath the feet of the archer is the same, although it is somewhat coarser and more irregular.

Subgroup D, 210–12

The profile on the obverse of this subgroup is closely related to that on the preceding subgroups, although the hair hangs down in shallow, broad waves. The crescent moon and star cut through the dotted border as well, and the earring is open at the bottom center. The cap of the archer on the reverse is long in the back, and the last letters of the legend are separated. The two letters beneath the feet of the archer are the same as on the preceding coins.

Subgroup E, 213–42

The most noticeable particularity on the obverse of this subgroup that the moustache is turned up at the ends instead of down as previously was the case. The beard is trimmed squarely under the chin, and the hair falls in shallow waves in a pear shape. The crescent moon and star seem not to have been depicted at all. Instead of the necklace, the only detail that is recognizable at the neck is a double neckline.

On the reverse, the archer is wearing the typical cap and is holding a very small bow. The last two letters of the legend are separated, in some cases the final letter is positioned so low that it appears to be on the same line as the two symbols beneath the feet of the archer, a series that is the same on all the coins of the main group (see in particular

219, 223, 226, 232, and 233). There is no o beneath the mint symbol; instead, the Δ is often moved further to the right so that the point projects into the Π (227, 231, 232, 235, 236, and 240).

Included in this subgroup is 242, the reverse of which is exactly like those already described. The obverse with the turned up moustache, the trimmed beard and the round neckline is also comparable, but the hair style with its stepped waves is more like that on Sanabares' coins.

Subgroup F, 243–47

Five coins in group 12 bear the mint mark ꟼ and, following Sellwood, were struck in Traxiana.[33] The obverse is very similar to that on coins in subgroup A, but the strands in the knot of hair are more crisply and closely curled. The reverse of coin 243 is, as far as it is still recognizable, like the somewhat coarser reverse of subgroup C, the last two letters in back of the archer are in both cases consecutive. The series of angles still preserved beneath the feet of the archer is comparable to that on coins in the main group that have already been discussed. On coins 244 and 245, other letters have been added to the right: 245, I; 244, I Ɔ. These may be traces of the word ΒΑΣΙΛΕ, although on coins of Sanabares this inscription began further to the left and then ran upward behind the back of the archer. Two coins, 245 and 246, have an angle behind the head of the archer. Above that there is another letter, rather like a P tipped toward the right, perhaps an Aramaic qōf. Whether these are traces of another name cannot be determined, given the fact that there is so little preserved. There seem to have been other letters or symbols on the extreme left edge of both coins. The short cap of the archer on 246 is reminiscent of subgroup C.

Also classified with this group is 247. Its obverse is in bad condition, but the right part of the reverse is clear and the mint mark is crisp. The series of letters that begins above the bow of the archer recalls those of group 11. Beneath the Λ at the side there is another letter but it can no longer be identified.

[33] Sellwood, p. 13.

Group 6, 31–37

One group of coins is very closely related to coins of Vologases I, 51–78 A.D. Comparable pieces are Mitchiner, *Indo-Parthians*, 654–56, and Sellwood, 70.13 and 71, especially in the treatment of the beard and the earring. The hair on group 6 coins, however, is divided into only three layers. This is usual for coins of Sanabares but not for those of Vologases I, on whose coins there are usually five. The Vologases symbol Ϙ is on the reverse at the back of the archer.[34] There is a Π beneath the bow on each coin, indicating the mint at Margiana. The word BACIΛC seems to have appeared at both the top and the bottom of the coin, the letters forming a circle. This orthography, in which the Σ is replaced by ɯ, has parallels on coins of Vologases I.[35]

The most carefully engraved coin in this group is 31. The beard is defined by slightly wavy lines while it is represented only by straight strokes on other coins. The letters CIΛC can be recognized at the bottom of the reverse but traces of other letters cannot be deciphered. The letters CIΛC are also to be found at the bottom of 32, although the engraving is coarser. On the obverse there are traces on the forehead that were part of a crescent moon. Closely related to this is 33, which bears traces of CIΛ above the bow on the reverse and to the right CV(?). Also very similar is 34, with traces of IΛC at the bottom, and 35 bears CIΛ above the bow. Coin 36 is very coarse in execution and the traces of the legend on the reverse are illegible.

On the basis of style, 37 is part of this group, although the king's cheek is clean shaven and the earring is therefore further forward, exactly as on Vologases' coins. There is no Vologases symbol on the reverse, however. The word BACIΛ began at the left, behind the head of the archer; and A is clearly recognizable preceding this and further down there are traces of other letters. If the name of the king preceded the word BACIΛE as the parallels suggest, the name will have ended with an A; however, no such royal name is known for this area. In

[34] Vologases adopted this symbol from the Achaemenids who used it frequently: Hill *BMC*, Persian Empire, 15, 27, 50, 122, and 163.

[35] Sellwood 70.10 and 71.1.

addition, if **BACIAE** appeared on this coin twice, there was only enough space for a very short name or for an abbreviation.

The coins in this group thus combine features of Sanabares' coins with features of the coins of Vologases I, and especially the Vologases symbol. These may be coins of Vologass III, ca. 105–47.[36]

Group 5, 22–30

Classification of this group of coins is very difficult. They are very worn, perhaps because they were in circulation longer than most of the coins considered thus far, the coins which have been attributed to Sanabares II and his successor. If so, they must have been struck before the reign of Sanabares.

No consensus has been reached yet regarding the attribution and dating of these coins. Beside being stylistically similar, they all have a Π mint mark on the reverse. W. Wroth ascribes two coins of this style to Gotarzes,[37] and K. W. Dobbins inclines toward Gotarzes II.[38] Mitchiner, however, regards this style as that of Sanabares II.[39] A comparison of such coins with those from the hoard seems to argue against the earlier attributions. Some details, in fact, seem to speak for attributing the coins to Vardanes I. For example, the obverse can be compared with Mitchiner 648,[40] especially with the third one in the top row. Sellwood 64.37 also seems to be a coin of this group, particularly when his legends ii and iii are considered.

Because of their worn condition, fine detail is not recognizable on these coins. The figure in the portrait on the obverse has a hair style of several layers, usually three, which evidently caused Mitchiner to attribute these coins to Sanabares II. The star and crescent moon in front of the forehead of the ruler do not cut through the dotted border. The star on these coins is always made up of serveral dots, usually five, sometimes six, which are grouped around one dot in the center (5:

[36] Cf. Sellwood 78.12, where a fragmentary legend is mentioned.

[37] Wroth *BMC* 55 (pl. 27, 7) and 56.

[38] Dobbins, p. 138.

[39] *Indo-Parthians* 1154, second row, center.

[40] M. Mitchiner, *Indo-Greek and Indo-Scythian Coinage*, vol. 5, *Establishment of the Scythians in Afghanistan and Pakistan* (London, 1975).

22–25, 28; 6: 26, 27, 29, and 30). This partiality to the use of dots is also to be observed on the reverse where the feet of the Π, the symbol for the mint, always end in a thick dot, a feature that is also to be observed on the coins of Vardanes I as illustrated by Mitchiner 648.

The legends on drachms of Vardanes I are quite barbarized, as is evident in Sellwood 64 legends ii and iii. On the hoard coins there seems to have been only one row of letters around the edge, beginning to the right of the archer's head with ΛΠΜ, the third letter presumably an E, so that the series is to be read as ΑΠΕ. A cleanly represented □ stands out on the right side; it is followed by a V. The preceding, uppermost letter is not clear. While there seems to be an I on coin 55 in the British Museum, which would suggest the name of the month ΑΠΕΛΛΑΙΟΥ — the two letters ΛΑ would thus have been lost at the turn from the horizontal to the vertical axis — the letter in question on the coins in the hoard ends at the bottom in an arch to the right and therefore looks more like a C or a B. Beneath the archer's bow, a Λ projects up into the large Π, the two together interpreted by Sellwood as the symbol for the mint at Aria.[41] But it rather looks like a V which should be read from the middle of the coin together with the letters that follow on the left OC, and another letter that can no longer be identified. The mint at Margiana would then be the logical choice, given the position and size of the dominant Π.

Traces of a Vologases symbol are clearly recognizable behind the backrest of the archer's seat on 23. These traces are less clearly discernible on 22. The symbol is also to be found on other coins of Vardanes I, e.g., on dichalkoi.[42] Therefore, several factors suggest that these coins can be attributed to that ruler, a little before the middle of the first century A.D., an attribution also supported by the state of preservation of these coins within the framework of the coins in the find as a whole.

Group 3, 12–17

A further group of coins is very worn and bears witness to the fact that the coins must have been in circulation for some time. The details

[41] Sellwood 64.37.
[42] Sellwood 64.39 (from Mithradatkart).

are obscure and so classification is very difficult. Among these coins, however, there is one (12) that corresponds to Sellwood 62.12 and can therefore be attributed to Artabanus II. To the left of the obverse portrait the Nike whose arms are raised to crown the king is still readily recognizable, while the one that should be behind the ruler's head was off flan. Of the legends on the reverse, the ΛΣΙΛΕ at the top and ΣΙΛΕ plus the beginning of another letter at the bottom are still legible, in each case, therefore, the word ΒΑΣΙΛΕ; on the right side, running from bottom to top, there are the letters ΑΡΤΛ, the beginning of the name Artabanus. Its mint symbol is also Π.

Several other coins in the find can be grouped with the example mentioned above. They are similarly worn and may have been struck about the same time. Other parallels can be established as well; 13, e.g., has a hair style and beard comparable to those on 12, but the portrait is smaller and more of the neck and torso can be seen. Perceptible traces of the Nikes crowning the ruler can still be seen to the right and left of the head. The reverse bears a legend with the letters in the same order, but it is poorly preserved. The figure of the archer is sunk down into itself so that his head is beneath the upper edge of the bow; above his head the letters ΒΑCΙΛ are recognizable, beneath the archer the letters ΒΛC are just barely legible; the mint mark is Π. On the left, behind the archer's backrest, there are traces of three more letters, probably ΟΥ and one other.

Of the same type but even more worn is 14. The letters ΒΛCΙ can just barely be identified on the reverse at the bottom. Also in this group is 15; traces of the Nike behind the head are preserved on the obverse, the legend on the reverse is worn beyond recognition. On 16 the Nike behind the head is still recognizable, while the individual letters of the legend on the reverse are legible but make no sense. The legend appears to have degenerated even further from the state on the preceding coins, suggesting that the issue was from a somewhat later date. These observations also apply to 17. Again there are traces of the Nikes preserved to the left and right of the head on the obverse; on the reverse, individual letters are still identifiable but the context is unclear. The series on the right seems to read ΟΥΣΙΟ from top to bottom.

Since these coins are so poorly preserved it is difficult to attribute them to a ruler, especially since material for comparison is lacking.

K. W. Dobbins, who illustrates a coin from this group, is unable to decide between Vardanes I and Gotarzes II.[43] Mitchiner, on the other hand, regards comparable coins as imitations from the late second or even the third century.[44] As better preserved and more numerous coins from the mint in Susa show, a corresponding treatment of hair and beard is to be found on coins of Artabanus II as well as of Vardanes I. The closest parallels are Le Rider, plates 19 and 20, 224–26. In some cases the strands of hair run downward diagonally toward the right, as on the coins in this find (especially his 225.1 and 226.6; cf. 14 and 15 here). This hair style seems to be typical in particular for Artabanus II, while on coins of Vardanes I the strands are more often slightly curved (cf. Le Rider 228–33). Coin 248 from Susa belongs to this group, for example.

One of the coins can be ascribed with certainty to Artabanus II (12 = Sellwood 62.12). The following coins have the characteristic hair style, the Nikes are similar to those on other coins of Artabanus II, and the coins are in the same state of preservation, all suggesting that the group was struck under Artabanus II and the coins are therefore not later imitations. All the coins in this group bear the mint symbol Π, presumably for Margiana.

Group 4, 18–21

A group of four further coins in the find (18-21) follows the coins examined above. They are similarly worn, which in itself suggests that they were issued at more or less the same time. Insofar as the state of preservation permits comparisons, they seem to correspond to Sellwood 63.16, but there are no illustrations of examples in Sellwood. Characteristic features are still the square-cut beard and hair that is depicted in almost vertical lines. A noticeable feature is the large double bow of the diadem projecting to the right. These characteristics are also to be found on coins of Gotarzes II[45] and Artabanus III,[46] as is also indicated by Sellwood. In contrast, the star above the crescent in front of the

[43] Dobbins, 7.
[44] Type 1157 (first two coins).
[45] Sellwood 65 and 66.
[46] Sellwood 74.

forehead of the king is to be found among comparable coins only on those of Artabanus II.[47] The four coins in this group are probably also attributable to Artabanus II. A further common characteristic is the legend on the reverse of 20 which forms a close parallel to that on 17, although the degeneration of the letters in the present group is more advanced. BΛCI can be discerned with some effort above the archer on 19; on the right, perhaps the series APTA was originally depicted.

A relative chronology for the coins of Artabanus II in this find can thus be established on the basis of the above observations: it begins with 12 (corresponding to Sellwood 62.12), continues with 13–17, and closes with 18–21.[48]

Group 2, 8–11

Another group of coins in this find is even more worn than the coins of Artabanus II. None of the details that would permit a certain classification of the coins is preserved. The still recognizable forms of the portrait, however, exhibit certain characteristics that enable us to narrow down the circle of possible rulers considerably. The beard is pointed and the hair style has an unusual triangular form and stands out at the back. This style is to be found for the first time on coins of Orodes II,[49] and then on coins of his son, Phraates IV,[50] whose own son, Phraataces, adopts it as well.[51] On the Phraataces coins there is often another detail also: to the right and left of the portrait head there are two Nikes crowning the king.[52] Examining the hoard coins carefully with this detail in mind, on 8–10 there are traces of these Nikes and thus they can be attributed to King Phraataces.

[47] Cf. the illustration, Sellwood 63.12.

[48] The coin illustrated in Mitchiner, *Indo-Parthians* 1160, bottom row, center, also belongs to the late group.

[49] Sellwood 48.9 and 48.10.

[50] Sellwood 50.15, 51.44, 52.10 ff., esp. 52.39 (of which there is unfortunately no illustration) and 54.7 ff., and Mitchiner, *Indo-Parthians* 644.

[51] Sellwood 56.6, 56.13, and 57.13, esp. 14 (no illustration), and Mitchiner, *Indo-Parthians* 645.

[52] Sellwood 57.13, 57.14, and 58.9 (limiting the selection to the drachms).

Group 1, 1–7

A group of several coins that is even more poorly preserved exhibits the characteristic hair style of group 2, in so far as it can be discerned, in an even more exaggerated form. The first of these can most readily be compared with coins of Phraates IV, Sellwood 54.9,[53] 2–7 with Sellwood 56.13 (= Mitchiner, *Indo-Parthians*, 645, a coin of Phraataces). They can thus be classified chronologically with the coins discussed above.

The next two, 6 and 7, are distinct from the others in that they were struck at another mint. There is a large T beneath the archer's bow, which could indicate Traxiana. This letter, however, is cited in Sellwood 52.25, Phraates IV, which he assigns to Susa on the basis of the symbol above the bow. Whether this symbol was also present on the hoard coins can no longer be determined.[54] On 6 at least there seems to have been a series of letters above the bow.

Group 14, 249–66

One small, distinct group of coins in the Getty find differs fully from all the other coins. It comes from a completely different area, Elymais, and the coins were struck in Susa. Since finds in this area are far more numerous than in the eastern provinces, it is possible to establish a tighter relative chronology; but there is still, unfortunately, great uncertainty with regard to the precise dating of these coins. While in earlier numismatic literature attempts were made to assign these coins to individual rulers, more recent literature is far more reserved in this respect.[55] Le Rider concludes that in about 75 A.D. the Elymaean capital was moved from Seleucia to Susa and that this is to be seen in connection with the opening of a new mint there.[56] Thus, all of the small copper coins of group 14 must have been struck after this time.

Subgroup A is anomalous and will be discussed later.

[53] This is similar to his description of 52.39, of which there is unfortunately no illustration.

[54] Indeed, it is not yet clear which mint ⋈ represents.

[55] In particular the detailed treatment in "Monnaies des rois Elymaïde" and Le Rider.

[56] Le Rider, p. 429.

Subgroup B, 250–52

Coins 250–52 are representative of a type that has been attributed by Allotte de la Fuÿe to Orodes III.[57] G. F. Hill concurs in this opinion.[58] A king in profile left is on the obverse of 250. There is a double diadem around his forehead above which there is a large knot of hair. Three rows of curls are arranged in a wave backward where they form a loose bunch at the back of the neck. The ruler's beard is pointed, there is a torque around his neck. On the left side there is a legend reading from top to bottom between the profile and the surrounding dotted border. The letters can be regarded as either Aramaic or Parthian, וורוד מלכא.[59] This legend can be read as WRWD MLK('), "King Orodes." Orodes was the most frequent name among the Elymaean kings of the first and second centuries A.D.[60] Since it is so common a name, it is not possible to attribute the coin to one particular king without further identifying marks, especially since it is not even known how many kings of this name there were.

The reverse carries the bust of a woman. While the upper body is shown frontally, the head is turned left and shown in profile. The surface is very worn. There is a wavy line leading from the back of the head; it was originally made up of individual dots and ended in three bands. It can no longer be determined whether this represented a braid or, for example, the ends of a diadem decorated with beads. On the left edge small traces of a legend are identifiable.[61] Presumably it was the same legend as is completely preserved on 251 which, with 252, is comparable to the coin just examined, but there are small differences in detail.[62]

The obverses of 251 and 252 again show the king in profile left. The bunch of hair on the top of his head is somewhat narrower than on 250;

[57] "Les Monnaies de l'Elymaïde," *RN* 1919, pl. 2, 22; p. 82, type a; Allotte de la Fuÿe, pl. 14, 162–68.

[58] Hill *BMC*, type B f; pl. 42, 5.

[59] See also W. B. Henning, *Asia Major* 2 (1952), p. 166, n. 1.

[60] Henning, p. 167; Le Rider, p. 429, nn. 1 and 2.

[61] This coin is most comparable to Allotte de la Fuÿe 164.

[62] Comparable pieces are Allotte de la Fuÿe 167–68; Allotte de la Fuÿe, *RN* 1919, pl. 2, 23; Hill *BMC*, pl. 42, 6; and "Monnaies des rois d'Elymaïde," pl. 2, 186 (the reverse of this coin has been confused in the illustrations with 183 to the left).

behind this there are two thin, parallel arched-lines to be seen, probably the bow of the diadem. On 251, the hair in the back is first taken together close to the head and then rounds out in a bunch. The beard is dotted and ends in a point. To the left of the head on 252 an anchor is clearly recognizable; it was presumably present on 251 but has been worn off. The anchor was a Seleucid symbol[63] that was adopted by the Elymaean kings and became a preferred sign, as can be seen from other coins in this find.

A bust of a woman is depicted on the reverse, similar to that on 250. The upper body is not, however, shown frontally but in three-quarter view toward the left. The robe is gathered, the top of the upper arm can be seen. There is a torque around her neck. The head is covered with short curls from which a braid-like form at the back of the head stands out. To the left of the portrait there is a legend with rather unusual letters which reads from top to bottom. There are only traces of this legend still preserved on 252, but on 251 it is preserved quite clearly. These are Aramaic letters in a form that is common for Elymais:[64] ﻦﻔﻟﻭ WLP'N or "Ulfan." This must therefore have been the name of the queen, the wife of this certain Orodes. It is one of the rare cases in which a queen is depicted and even named on the reverse of a coin. The only other examples in the realm of Parthian coins are those of Phraataces, which bear a portrait of his mother Musa who was also his wife.[65] The other coins of the Elymaean kings have an image of a divinity on the reverse.[66]

Subgroup C, 253–57

The obverse portraits of subgroup C are similar to those described above, see particularly 253, although the bunch of hair at the back of the neck is smaller. There is also less hair on the top of the head above the double diadem, just one row of curls, and only a small bunch of hair

[63] Allotte de la Fuÿe, p. 204.

[64] Cf., e.g., the inscriptions of Tang-e Sarvak: Henning, *Asia Major* 2 (1952), pp. 151–68, esp. p. 164 and list of signs, p. 168.

[65] See, e.g., Sellwood 58.

[66] It should be noted, however, that Musa is also described as ΘΕΑ or "goddess" on the coins.

above the forehead. The bow of the diadem stands way out above the bunch of hair at the back of the neck (254-57). The beard is dotted on the cheeks, and two further rows of dots run downward. An anchor is clearly recognizable behind the head on 257. Whether the traces behind the heads on other pieces in this group can also be identified as anchors (see particularly 254) can not be determined, given the poor state of preservation. The robe, the edge of which is still partly recognizable on the neck, is gathered in a special way. The edge curves around the neck; leading away from this curve is a line straight down somewhat to the left of the left upper arm,[67] and a further line curves lightly around the left upper arm. Further folds liven up the robe in the areas between.

The reverses have a standing Artemis. This represenation goes back to a late classical type, the Versailles Artemis. The same type is to be found on coins of Mithradates II, ca. 124/3–90, from the mint in Susa.[68] The figure is moving toward her left, holding her bow in her outstretched left hand and pulling an arrow out of the quiver on her back with her right hand. On the coins, she is looking in the direction in which she is moving. On 253 and 255 the figure is represented in full view, on 254, which is smaller, the head and the feet are cut off. Coins 256 and 257 show about three-fourths of the statue, the legs having been cut off below the hem of the short gown. This allows the upper part of the figure to be depicted in somewhat larger scale, and Artemis's headdress is therefore more clearly recognizable. She is wearing a crown that stands far out over the forehead and the back of the neck and ends in both places in a round, volute-like form. Between these forms, stalks stand upward like rays, each of them ending in a pellet (see also 255). It has been conjectured that this headdress is to be regarded as a reminiscence of the goddess Nana/Anahita who was greatly venerated in Elymais.[69] She merged with the Greek goddess, Artemis, and her main temple stood in Azara.

[67] This is most clearly recognizable on 256 and 257, since the fullness of the other folds has not been represented. Also these two coins differ slightly from the others in the group in regard to hair style.

[68] Le Rider, pl. 15, 147.

[69] Allotte de la Fuÿe, p. 196.

Subgroup D, 258–59

The crown described above is readily recognizable on coins that already belong to a further subgroup which is, however, more poorly preserved (258 and 259). On these coins only the head of the goddess is shown, making a more detailed representation of the crown possible. It consists of two rows of stalks, one row about half the size of the other, each of the stalks ending in a pellet. The goddess is also wearing an earring from which a pellet or bead is suspended. There is an anchor behind her head. According to Pliny, there was an Artemis temple in Susa which was the most highly revered temple in the whole area.[70] It is therefore understandable that the image of Artemis was a preferred subject for coins.

The obverse again shows a king in profile left. The double diadem has a bow at the back from which there are two bands pendant. There is a thick knot of hair on top of the head, the back of the neck is cleanly shaven. The beard is badly worn on both coins and therefore no longer clearly describable. The edge of a robe can be seen on 258 with the same characteristic lines as in subgroup C, one line around the neck, and one leading straight down from the neckline in front of the left shoulder. On this coin there is also a legend on the left in front of the king's head: ـدﺍﺧ١٧١, WRWD MLK', "King Orodes." Thus, there is again a king of this name whose portrait differs from the others in the hair style. These coins are generally attributed to Orodes IV.[71]

Subgroup E, 260–61

Two other coins (260 and 261) are very similar to the previous type and also show the king with a cleanly shaven neck. There is no knot of hair on the top of the head, however, only a row of curls. The beard on the chin hangs down in two long rows of curls. The robe is characteristically gathered — it is clearer on 260 than on any of the other coins. Neither legend nor attributes are present. Because of the unusual short

[70] Allotte de la Fuÿe, p. 194.

[71] Allotte de la Fuÿe, pl. 14, 171; Allotte de la Fuÿe, *RN* 1919, pl. 2, 28 and 29; "Monnaies des rois d'Elymaïde," pl. 2, 187–88; pl. 14, 175; Hill *BMC*, B g 1, and pl. 42, 8; Göbl 2, pl. 101, 2077; Mitchiner, *Ancient World*, p. 125, 720.

hair and the shaven neck — features which are not to be found on other coins — it can be assumed that these are coins of the same Orodes as in subgroup D. On the reverse there is a full-length image of Artemis, comparable to that in subgroup C. Traces of the rayed crown are to be found on both coins. On 260 Artemis's head is inclined to her left.

Subgroup F, 262–66

A further group of Elymaean coins in the find at the Getty Museum stands out because it has a frontal portrait of the king. This is quite unusual and appears only very rarely on Parthian coins.[72] A. de la Fuÿe attributes these coins to Orodes III (cf. subgroup B).[73] Le Rider compares them with coins of Vologases V, which are indeed very similar, and thus arrives at a basis for dating them to around 200 A.D.[74] The king has a small knot of hair above the double diadem, with small knots to the right and left covering his ears. The bow of the diadem is to the right of the coin; the pendant ends emerge from beneath the right knot of hair. The king has a curved moustache and a chin beard that hangs down in two rows of curls.

The reverse design is similar to that of subgroup D, 258. It shows the head of the goddess Artemis with the unusual rayed crown but is, on the whole, more coarsely rendered. The hair is formed of little bulging curls. There appears to have been some kind of necklace with pendant beads around the neck. There is an anchor behind the head; it can be seen in full on 262 and 265; there are only traces left on 263, 264, and 266.

Subgroup A, 249

One single Elymaean coin in the find differs considerably from those examined up to now. The portrait of the king is relatively small. A

[72] During the first century B.C. on coins that are perhaps to be attributed to Darius (Sellwood 35), then e.g., on coins of Artabanus II (Sellwood 63.1–5), Vologases III (Sellwood 79.50), and Vologases V (Sellwood 86).

[73] Allotte de la Fuÿe, pp. 177 ff. (cf. 157–61) "Orodes III" (see table); de la Fuÿe, *RN* 1919, pl. 2, 26.

[74] "Monnaies des rois d'Elymaïde," pl. 2, 183 (the illustration of the reverse has been exchanged with that of 186 on the right).

knot of hair rises from the top of the head; it is gathered together to form a stem-like shape near the head and then spreads out further up. Two bands float out to the back right from the stem-like shape. A knot of hair formed of single round locks hangs down on the back of the neck. Above this there is a small bow, below it two bands pendant. The beard is made of coarse dots and circles both cheeks and chin. From the nearly semicircular neck of the robe there is a perpendicular line from the shoulder down; there is a second, dotted line running parallel to it. Traces of an anchor are recognizable on the right behind the head.

On this coin, Athena is depicted on the reverse instead of Artemis. She is leaning on a spear with her right hand, her left hand rests on a shield that is standing on the ground. Her right leg seems to be bent, her foot must have rested on a slight rise. The depiction of this Athena type on the reverse of Elymaean coins seems to have been limited to this ruler. Which ruler it is, is difficult to say. The portrait is most closely related to that on coins of Khusrau I (Osroes), which are, however, not as coarse.[75] There is a standing Athena on the reverse of coins of Vologases III, for example;[76] he was a contemporary of Khusrau I, so perhaps both rulers chose this motif to indicate their rivalry.

Group 13, 248

Another coin, which is also the only representative of its type in the find, is also ascribed by Le Rider to the mint at Susa (248).[77] Given the parallels with comparable pieces,[78] it must be a coin of Vardanes I, the

[75] See also Le Rider, pp. 429 ff., pl. 73, 30–36; Petrowicz Sammlung, *Arsaciden-Münzen* (Vienna, 1904), pl. 21, 12, where there Artemis is depicted on the reverse. Allotte de la Fuÿe, pl. 14, 184 and 186, ascribes these coins to Vologases II or III (in Wroth *BMC*, 186 is ascribed to Vologases I, pl. 29, 8). Mitchiner, *Ancient World*, 723, identifies this ruler as Prince B and dates the coin to ca. 200 A.D.

[76] Mitchiner, *Ancient World*, 676 (Chalkous).

[77] Le Rider, pl. 20, 228, 229, and 231–33.

[78] See above, n. 77; see also Wroth *BMC*, pl. 26, 3 and 4; "Monnaies des rois Elymaïde," pl. 1, 122 (described there as "roi uncertain").

last Arsacid king, who minted coins at Susa until the Elymaean kings took power around 45 A.D.[79]

The coin is unfortunately in a very poor state of preservation. On the obverse it shows the king in profile left. There is a double diadem around the hair which hangs down in a gentle wave. The beard is short and rounded. There is a symbol on the forehead that is also to be found in the same form on examples illustrated by Le Rider. The reverse is so poorly preserved that only an archer seated right can be presumed at all.

[79] "Monnaies des rois Elymaïde," p. 426.

HISTORICAL PERSPECTIVE

The majority of the 266 coins in the hoard are from a single region that today includes eastern Iran, Afghanistan, and Turkmenistan. Most of them, i.e. 144 coins, can be ascribed to the mint in Abarshahr, present-day Nishapur; perhaps 48 of the coins were struck in Aria, present-day Herat; and possibly 77 in Margiana or present-day Merv.[80] Only 7 of the coins come from a different mint in this area, from Traxiana, which is probably today's Dāmghān. In addition to the large number of coins that were struck in the northeastern part of the Parthian kingdom, there is a small group of 19 coins that was struck by the Elymaean kings and one of their predecessors in Susa. They were probably carried eastward through trade and thus came into the possession of the person who hid the present find. Palmyrene inscriptions speak of trade routes leading to Susa and Scythia.[81] Isidore describes Parthian stops along the silk route, among them Nisa and Merv;[82] Strabo mentions a route from Persepolis to Carmania, leading through Sistan to India.[83] The appearance of coins from Susa this far east is therefore not surprising, and their presence here can perhaps provide information concerning the problem of the chronology of the coins from the main area in question, a subject that is still beset with great difficulties.

One striking feature of the find is that it is made up entirely of coppers — there are no silver coins. But many scholars have come to

[80] The exact number of coins from Aria and Margiana cannot be determined with certainty due to similarity of type and worn specimens. In fact, the identification of these two mints is based on Sellwood's attributions (pp. 12–15) and some coins are so worn that the mint cannot be identified with any certainty at all.

[81] H. Seyrig, "Inscriptions grecques de l'agora de Palmyre," *Syria* 22 (1941), pp. 252–63; J. Starcky, *Palmyre* (1952), p. 74.

[82] Colledge, p. 79.

[83] Colledge, p. 80.

the conclusion that silver must have become very scarce in the Parthian kingdom by the end of the first century A.D., and particularly during the second century.[84] In Susa and in the eastern part of the kingdom, drachms were no longer issued in silver but in copper, their weight indicating that they were supposed to take the place of the silver coin.[85] In the east, the last documented silver coins are from the reign of Sanabares I (ca. 135–60), after that only copper coins are known.[86] Since most of the coins in this find are later than that, it is understandable that no silver coins are included.

The earliest coins in the find (group 1) were struck under Phraates IV (ca. 38–2 B.C.)[87] and his son Phraataces (ca. 2 B.C.–A.D. 4). Since these coins are very worn, it is difficult to identify them more precisely. Coin 1 at least seems to be a coin of Phraates IV; it was struck at the mint in Margiana. Phraates IV was driven out of Mesopotamia for a time by Tiridates and spent the period ca. 29–27 B.C. on the high plateau occupied by the Scythians. There are therefore a whole series of coins of Phraates IV struck at eastern mints: Mithradatkart, Nisa, Aria, and Margiana. During his reign, there is a noticeable decline in the quality of the coins, especially in those from provincial mints.[88] In the case of four of the coins (2–5), it is not clear whether they are to be ascribed to Phraates IV or to Phraataces; four others can probably be ascribed to the latter (8–11). They were all struck in Margiana. Two other coins (6 and 7) are attributable to Traxiana. Coins from Mithradatkart and Nisa are also attested from the east for Phraataces. There are only a few coins struck by these two rulers in this find, and the poor state of preservation indicates that they were in circulation for quite some time.

There are no coins in the find from the two following Parthian kings, Orodes III (A.D. 4–6/7) and Vonones I (ca. 8–12). This comes as no surprise, since they are known to have issued coins only from western

[84] Colledge, p. 75, "... the coins became simply silver-washed bronze."

[85] Simonetta 1957, p. 50.

[86] David W. Mac Dowall, "The Dynasty of the Later Indo-Parthians," *NC* 1965, p. 147; Mitchiner, *Ancient World*, p. 365, cf. 2645–46 and 2647–48.

[87] Schippmann: 40–2 B.C.; Sellwood, p. 159.

[88] Sellwood, p. 160.

mints; no coins from eastern mints have been attested for these rulers up to now.[89] Vonones was defeated by Artabanus II (ca. 10–38).[90] During Artabanus's reign there were frequent revolts, and he had to retreat to the eastern Iranian plateau [91] where he probably came from originally.[92] Again there are various issues from eastern mints: Mithridatkart, Nisa, Margiana, and perhaps Aria.[93] There are ten coins in the find (groups 3 and 4) that can be ascribed to this ruler; they were struck in Margiana and they are also very worn. Artabanus II's death date is not known since the only mint that included dates on its coins, Seleucia, was independent at that time. He was followed by Vardanes I (ca. 40–45), who may have been his son.

Vardanes succeeded in re-establishing his power in Seleucia, but during his reign he was engaged in repeated conflicts with his brother, perhaps by adoption, Gotarzes II. Coins from eastern mints are known for both of these rulers. In this find, nine coins from Margiana (group 5) and one from Susa (group 13) can be ascribed to Vardanes I. He was the last king to strike coins in Susa.[94] These coins must also have been in circulation for quite some time.

Coins struck in Margiana are also attested for Vologases I (ca. 51–78).[95] Josephus, *AJ* 20.91, reports that Vologases hurried to defend Parthyene against the attacks of the Sacae and Dahae.[96] During his reign, however, Vologases not only had to deal with Vardanes II (ca. 55–58) [97] who drove him from his throne for a time, but he was also

[89] Schippmann, pp. 8–9.

[90] Previously identified as Artabanus III, cf. Debevoise, p. 270, and *CHI* 3, 1, p. 218.

[91] Sellwood, p. 196.

[92] Kahrstedt, p. 12.

[93] Sellwood 63.9. They would then have to be from a time before Aria was taken by Gondophares which, according to Kahrstedt, p. 34, was between 35 and 38 A.D.

[94] Le Rider, pp. 425 ff.

[95] Debevoise, A.D. 51/52–79/80, followed by W. W. Tarn, *The Greeks in Bactria and India* (1951), p. 52; Colledge, p. 179, 51–80; Schippmann, pp. 54–58, 125, ca. 51–ca. 76–80.

[96] Kahrstedt, p. 36.

[97] According to Sellwood, p. 223, Vardanes II was the son of Vologases; according to Kahrstedt, he was the son of Vardanes I.

attacked by the Romans. Weakened by these attacks, he had to renounce his claims to the east in 62 A.D.[98] Vologases I was the first Parthian king to use Aramaic letters on his coins.

Of the succeeding Parthian kings, only Pacorus II (ca. 78–105),[99] Vologases III (ca. 105–47 A.D.),[100] and Khusrau I (Osroes, ca. 109–29)[101] minted coins in Margiana. This was evidently the only mint in the east that remained under the control of the Parthian kings for a longer period of time, probably into the second century. The find in the Getty Museum contains seven coins struck in Margiana that are possibly to be ascribed to Vologases III (group 6).

During the first half of the first century A.D. in the east, Gondophares, the king of Sakastana (Sistan), enlarged his inheritance by adding Arachosia and India to his realm and extending his rule to Aria.[102] According to more recent scholarship, the dates of his reign are usually given as 19/20–ca. 55.[103] Only on the basis of numismatic evidence is it possible to establish a relative chronology for his successors. The first of them was Abdagases who would have come to power after 55. It is generally held that he was followed by Pakores, who, according to Simonetta, may have been a son of Gondophares.[104] Simonetta suggests a regnal period from 60 to 90,[105] while Mitchiner

[98] Kahrstedt, p. 83.

[99] Sellwood, p. 235; Debevoise, p. 270, 78–115/16?, followed by Tarn (above, n. 95), p. 352; Colledge, p. 179, 77–115; Schippmann, pp. 59ff., 126, cites three regnal periods: 77/8–86/7, 92/3–95/6, and 113/4–114/5.

[100] Colledge, p. 179, and Sellwood, p. 250; in Debevoise, p. 270, Vologases II with same dates; Schippmann, pp. 60–64, 126, 111/2–146/7.

[101] Debevoise, p. 270, Tarn, p. 352, and Sellwood, p. 258; Colledge, p. 53, 179, ca. 89–128?; Schippmann, pp. 59–64, 126, cites two regnal periods: 89/90 and 108/9–127/8.

[102] Pliny, HN 6.78, says that Aria, Arachosia, Gedrosia, and the Parapamisads were part of Gondophares' realm (Kahrstedt, p. 32).

[103] Aside from the coins, there is only one written source for dating Gondophares' ascension to the throne, the Takht-e Bahi inscription. It can be dated to his twenty-sixth year of rule, and the year is given as 103. Despite differences of opinion as to which era this year is to be assigned, there is more or less general agreement on the approximate dating of Gondophares.

[104] Simonetta 1978, p. 160.

[105] Simonetta 1978, p. 160.

places him between ca. 100–110 to 135 and assumes that Abdagases ruled correspondingly longer.[106] Pakores was followed by Sanabares.[107]

Of all the rulers in the history of the eastern provinces under the Parthians, the figure of Sanabares gives most frequent rise to discussion. His suggested dates vary by a century and a half. Dobbins, following Gardner, assumed in an essay in 1971 that Sanabares ruled at about the time of Christ's birth[108] — an assumption that is clearly precluded by the evidence of the coins already discussed; Mitchiner, on the other hand, sets the beginning of Sanabares' reign at about 135.[109] Sellwood establishes an intermediate date of ca. 50–65 for Sanabares I;[110] both he and Simonetta suggest that the extant Sanabares coinage may have been struck by two rulers with the same name.[111]

In the find at the Getty Museum, there is a relatively large number of coins (40, groups 7–10) that can be ascribed to Sanabares II, perhaps a son of Sanabares I; they were struck in Margiana. In the case of 51 other coins from Aria (group 11), it is not clear whether they also stem from the time of Sanabares II or from that of one of his successors. Simonetta assumes, however, that there were at least three other successors to the territories of Sanabares I;[112] these kings ruled, according to Simonetta, only in the northern part of the original realm of Gondophares.

A thorough study of the mints at which the individual rulers struck their coins indicates that it is necessary to distinguish between different

[106] *Indo-Parthians*, p. 394; *Ancient World*, p. 348.

[107] Mac Dowall (above, n. 17), p. 148, and A. D. H. Bivar, "Gondophares and the Shāhnāma," *Iranica Antiqua* 16 (1981), pp. 141 ff., also assume the same relative series: Gondophares, Abdagases, Pakores, and Sanabares.

[108] Gardner *BMC*, p. xlvi; Dobbins (above, n. 15), esp. p. 141.

[109] *Indo-Parthians*, pp. 348 and 365. In Simonetta's opinion (Simonetta 1978, p. 161), no more coins were struck in Sistan after 120, and he expresses surprise about the large gap that exists from then to the time of the first Sasanian issues.

[110] Sellwood, "The Ancient Near East," *Coins: An Illustrated Survey, 650 B.C. to the Present Day*, ed. Martin J. Price (1980), p. 253, 1198.

[111] Sellwood, pp. 304–5, is not sure, however, how the Sanabares of ca. 50–65 relates to the one of the same name who, in his opinion, appeared in Arachosia around 85 A.D. or later; Simonetta 1957, p. 50.

[112] Simonetta 1978, p. 161.

areas of sovereignity in the eastern part of the Parthian kingdom, something that previously has not been done by scholars. Gondophares' coins are from the eastern mints at Jammu, Taxila, Chach, Kandahar, and Ghazni; coins of Gondophares' successor Abdagases come from Taxilla, Chach, and a mint represented by the symbol 𐤀. This is usually the symbol for Ecbatana (Hamadan), but the Indo-Parthian kings are not known to have extended their rule so far west. It is more probable that this 𐤀 stands for the mint at Aria (Herat). Although Pliny reports that Gondophares added Aria to his kingdom,[113] this fact can be documented only through coins from the time of Gondophares' successor, Abdagases. The great expansion of the kingdom of Sakastan (Sistan) seems to have been only a temporary phenomenon. Pakores and Sanabares I, who are generally regarded as the successors to Gondophares and Abdagases, are represented only by coins from Aria. Their names are not found on coins from Sakastan or Arachosia nor on coins from mints further to the east:[114] this implies that Pakores and Sanabares ruled over a different area. The coins which they struck that appear in the Getty hoard are from a limited area, the provinces of Abarshahr, Margiana, and Aria.[115] In a later period, under the Sasanians, these three provinces formed the administrative district of Khorasan.[116] It can be inferred from this find that Khorasan was already a self-contained administrative district in Parthian times since one would otherwise expect to find coins from

[113] Above, n. 102.

[114] There, Sepadanes and Satavastra could be considered as possible successors. J. Hackin, "Répartition des monnaies anciennes en Afghanistan," *Journal Asiatique* 226 (1935), p. 288, reports, however, that of the coins that were found in the area of Kandahar 40 percent were struck by Pakores; he does not present the material which allows him to reach this conclusion, nor does he indicate from which mints the coins came.

[115] Assuming Traxiana was the Parthian site of modern Dāmghān (above, n. 10), it would have been on the western edge of the province of Abarshahr.

[116] They are listed one after the other in the inscription on the Ka'ba-ye Zardosht by Shāpūr I (ca. 240–70). See also P. Gignoux, "La Liste des provinces de l'Ērān dans les inscriptions de Šābuhr et Kirdīr," *Acta Antiqua Academiae Scientiarum Hungaricae* 19 (1971), p. 92.

other mints in the Parthian kingdom. It would seem, given the absence of coins of Gondophares and Abdagases from this area, that Khorasan was a separate district in later Parthian times.

The group 11 coins of Sanabares II or his successor were more roughly struck than those of the preceding group. They were followed by coins of a finer style, those of group 12. The ruler who commissioned these coins may have been a descendent of Pakores. These coins, 119 in number, represent the main part of the Getty find. Almost all of them were minted in Abarshahr (Nishapur); five of them were struck in Traxiana (subgroup F). The reverses of the Abarshahr coins are the earliest instances of mint names given in full, a feature that is usually regarded to have begun with the Sasanian ruler Varahran IV (A.D. 388–99).[117] Since these coins are so numerous in the find, it suggests that the hoard was hidden not too long after the reign of this ruler. But when was that? Here the Elymaean coins contained in the find may provide helpful information.

Due to the survey resulting from the Mission de Susiane, there is a good overall picture of the coins minted in Susa during Parthian times.[118] Of the Parthian kings, Vardanes I, ca. 40–45, was the last one to mint coins in Susa, and there is one example preserved in this find (group 13, 248). The Elymaean kings, on the other hand, began striking coins in Susa in ca. 75. One of the coins (group 14, A, 249) has been compared with coins of Khusrau I and Vologases III and may have been struck during the first quarter of the second century A.D. As the result of a study of the Elymaean inscriptions at Tang-e Sarvak, the place where Elymaean kings were crowned, W. Henning has proposed that King Abar-Bāsī, to whom subgroup C may be ascribed, came to the throne in 150.[119] He was followed by Orodes IV (subgroups D and E), who came to power in about 165–70. Orodes III (subgroup B) presumably reigned before them in the second quarter of the second

[117] Mitchiner, *Ancient World*, p. 139.

[118] Le Rider.

[119] "The Monuments and Inscriptions of Tang-i Sarvak," *Asia Major* 2 (1952), pp. 151 ff., esp. p. 176, but see also p. 178, n. 2.

century. In addition, there are some Elymaean coins in this group that are evidently imitations of coins minted by the Parthian ruler Vologases V (subgroup F).[120] They are remarkable for the fact that they bear a facing bust of the king, something which is to be found rather seldom on coins from Parthian times. It is reasonable to assume that these Elymaean coins are nearly contemporary with the Parthian ruler Vologases V, i.e., from around 200. The find as a whole can therefore only have been hidden after this time, presumably in the early third century. The Parthian ruler who minted the group 12 coins in Abarshahr will thus have reigned during the last decades of the second century A.D.

The Parthian kings from about the time of the Christian era until the middle of the first century, i.e., from Phraates IV to Vardanes I, are all represented by coins in the find at the Getty Museum; these coins are in a very poor state of preservation. They were struck in mints at Margiana, Aria, and Traxiana. The area in question must therefore have been under the suzerainty of the Arsacids at the time. After that, the names of Parthian kings appear only sporadically on coins from Margiana, as e.g. Vologases I, who had to renounce his claims to the eastern territories in 62 A.D. From about the turn of the century and at the beginning of the second century there are extant coins of Pacorus II, Vologases III, and Khusrau I, but only from Margiana. The seven group 6 coins in the Getty hoard seem to have been struck by Vologases III (ca. 105–47), but coins of his immediate predecessors in the second half of the first century are lacking in this find.

The province of Aria fell to the kingdom of Sakastan, presumably during the lifetime of Gondophares and, at the latest, during the reign of Abdagases. It was supposedly after his death, during the second half of the first century, that a local ruler from Aria, Pakores, succeeded in making the province independent of the powerful realm established by Gondophares and Abdagases in the east. Pakores' successor was Sanabares I. Nothing is known about the relationships of these local rulers to the Parthian kings further west, but the uninterrupted choice of the archer on the reverse of the coins indicates that they recognized a

[120] Le Rider, p. 430, pl. 74, 5 and 6; cf. Wroth *BMC*, p. 240, 23 and 29, pl. 35, 12 and 13, "Vologases IV."

connection with the Arsacids. What the situation was like in Margiana and Abarshahr at this time is unclear, although they may have been partly under the suzerainty of the Kushans.[121] Sanabares II, perhaps a son af Sanabares I, either added these provinces to his territory, probably during the second quarter of the second century, or possibly he was entrusted with the government of this provincial region (later called Khorasan) by Vologases III (just as the Sasanians were to entrust power to the local rulers there a century later). The numerous coin issues with their decline in style suggest that Sanabares II reigned for a very long time, although it is also conceivable that some of these coins were struck by one or even several successors who adopted Sanabares II's style.[122] A noticeable sharpening of style begins in the second half or last quarter of the second century with the issues of a succeeding ruler who struck coins primarily in Abarshahr. The reverse of these issues is similar to that of Sanabares II, while the obverse is reminiscent of issues of Pakores.

The find of copper coins in the Getty Museum therefore not only provides a significant amount of previously unknown numismatic material, but through its composition throws light on political developments in the eastern part of the Parthian kingdom in the first and particularly second centuries; it also provides clues toward establishing a chronology of the rulers there. The unfavorable economic situation of the times is made particularly clear by the fact that only copper coins were in circulation. The simultaneous presence of coins from a self-contained region in the northeastern part of the Parthian kingdom and coins from Elymais that made their way there over the trade routes provides welcome aid in dating the coins. Since the latest coins date from ca. 200, the find could not have been concealed any earlier than the beginning of the third century.

[121] See also Kahrstedt, pp. 37 and 82 ff.
[122] This seems to be in the case in regard to group 11 in particular.

SUMMARY

The find in the Getty Museum provides information about the chronology of the kings of Elymais, as well as about the rulers in the area of Khorasan. There are no certain dates contained in literary or other sources for these rulers and the coins provide no such dates either, since they are all undated coppers. The sequencing of the coins, however, does suggest a relative chronology for some of the individual rulers.

The relative order of the identifiable Elymaean kings in the second century A.D. is:

Ca. 100–125: an unknown king whose coins can be compared with those of Khusrau I and Vologases III

Ca. 125–50: Orodes III

Ca. 150: Abar-Bāsī

Ca. 165–70: Orodes IV

Ca. 200: an unknown king (Orodes V?) whose coins can be compared with similar coins of Vologases V.

The largest part of the Getty hoard is composed of coins of Sanabares II (groups 7–10, 38–77), Sanabares II or a successor (group 11, 78–128), and a ruler at Abarshahr (group 12, 129–242) and Traxiana (group 12, 243–47). These coins and the Elymaean coins in the find (groups 13–14, 248–66), along with other published coins, can be used to establish a relative chronology of the rulers who struck coins at Aria, Margiana, Abarshahr, and Traxiana, the area later known as Khorasan. This seems to have been an independent area which enjoyed a different status than the empire of the Indo-Parthians established by Gondophares to the east and which was also different from the Parthians to the west. These coins should not be assigned to the kingdom of Sakastan: they represent a separate, more or less independent administrative area. Their kings evidently were related to a family that was established in Aria.

The relative order of the identifiable kings of Khorasan is:

Ca. 50–100: Pakores secures the independence of his kingdom from the Indo-Parthians

Ca. 100–125: Sanabares I

Ca. 125–50: Sanabares II incorporates Margiana and Abarshahr into his kingdom; either reigned for a long time or had one or more successors who maintained his style of coinage very closely

Ca. 150–200: Unknown ruler of Abarshahr

The Getty hoard provides much new information about the eastern Parthians in the first two centuries A.D. For more specific details about the succession of kings and dates of individual rulers, however, new source material must be found. In any case, the numerous coins in this find — for which there are scarcely any parallels — make possible a new view of the rulers in the eastern provinces of the Parthian kingdom and of the borders of their realm. In spite of the modest material used, copper, and the poor state of preservation, these coins are of great importance for the history of Iran during the second century A.D.

PLATES

Plate 1

Group 1

Group 2

Group 3

Group 4

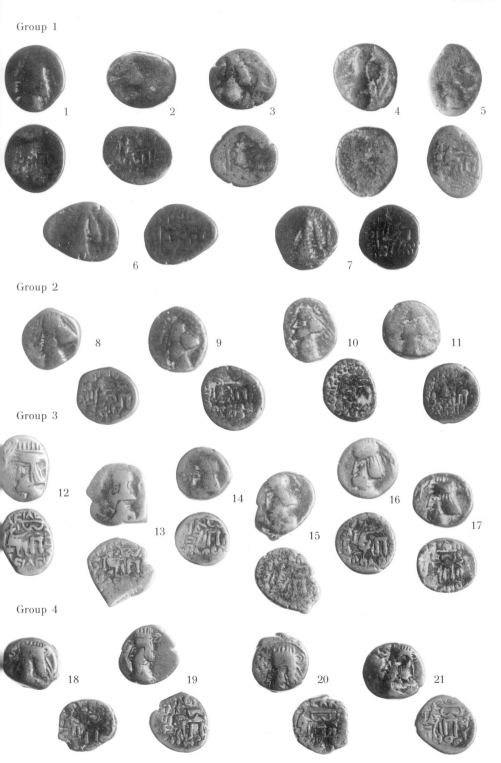

Plate 2

Group 5

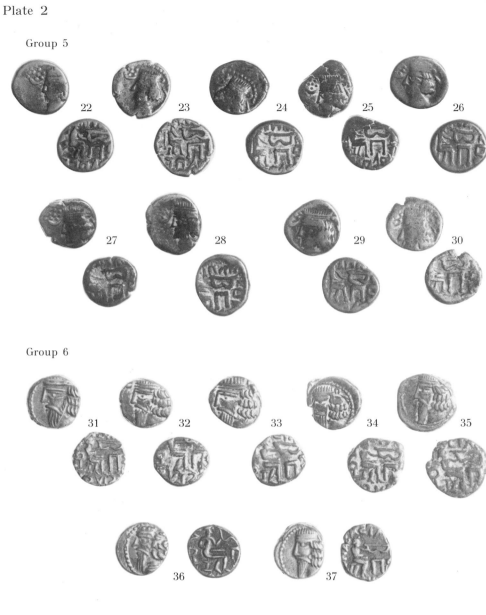

Group 6

Group 7

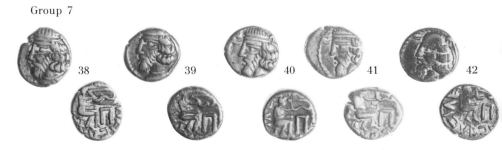

Plate 3

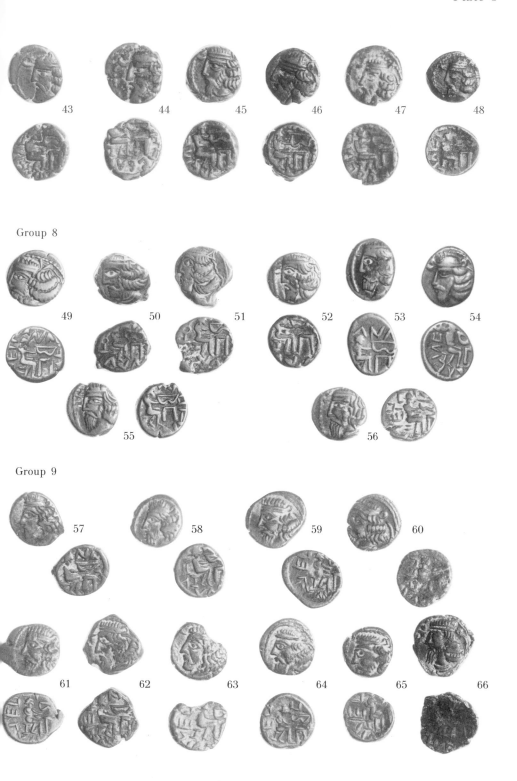

43 44 45 46 47 48

Group 8

49 50 51 52 53 54

55 56

Group 9

57 58 59 60

61 62 63 64 65 66

Plate 4

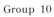

Group 10

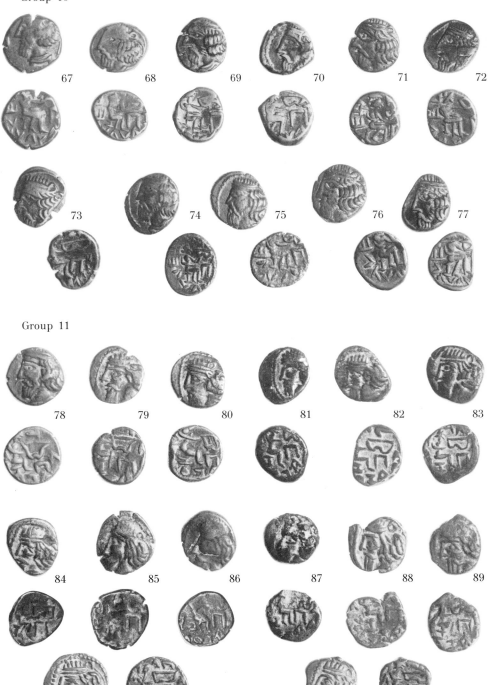

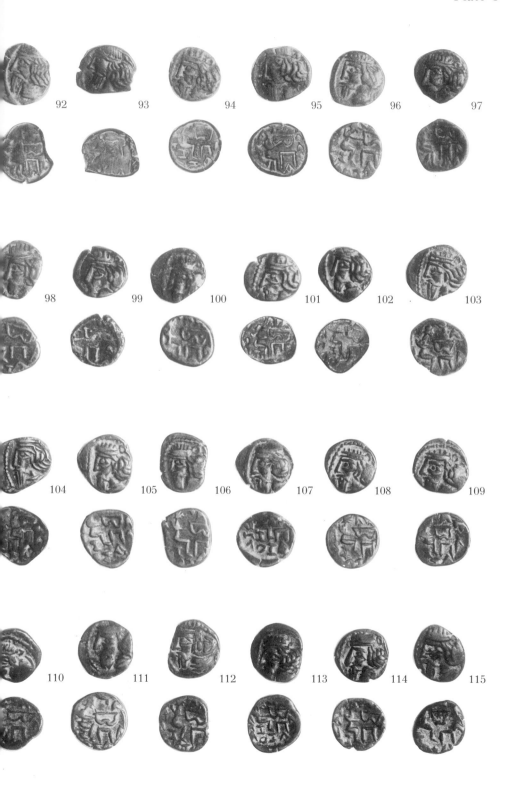

Plate 5

Plate 6

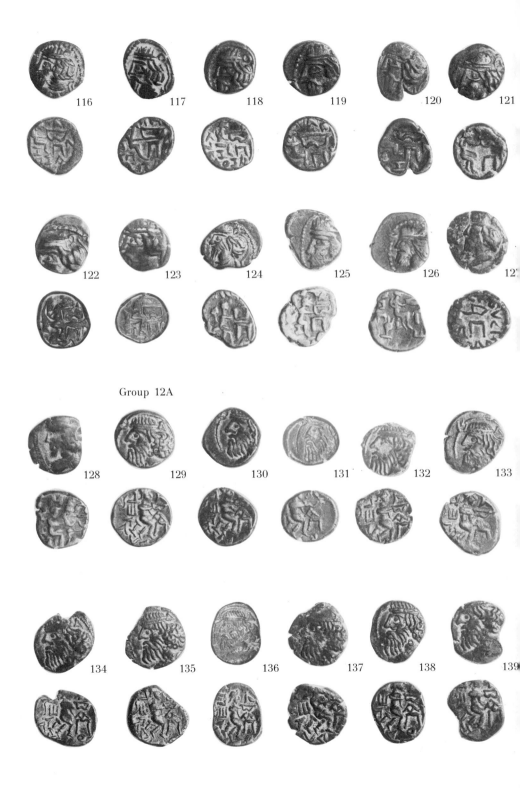

116 117 118 119 120 121

122 123 124 125 126 127

Group 12A

128 129 130 131 132 133

134 135 136 137 138 139

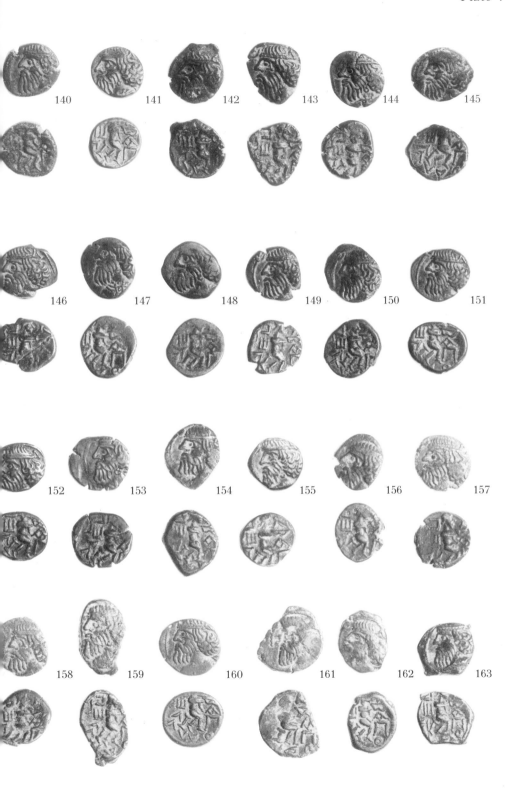

Plate 7

140 141 142 143 144 145

146 147 148 149 150 151

152 153 154 155 156 157

158 159 160 161 162 163

Plate 8

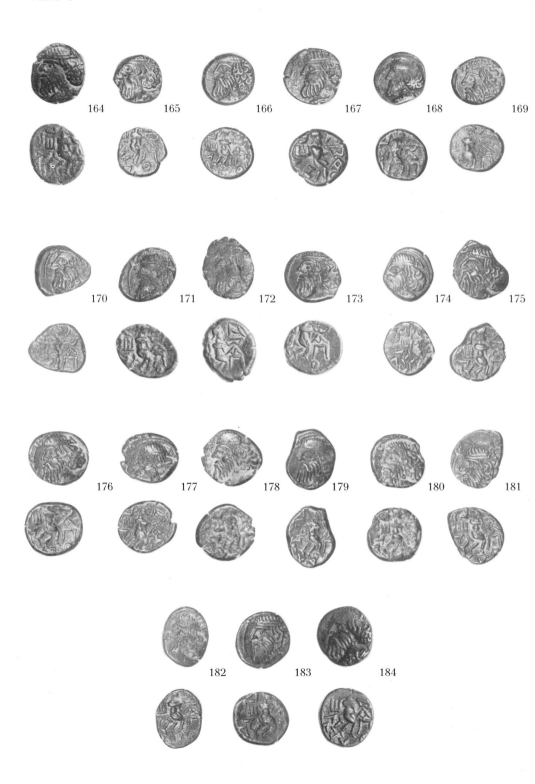

164 165 166 167 168 169

170 171 172 173 174 175

176 177 178 179 180 181

182 183 184

Plate 9

Group 12B

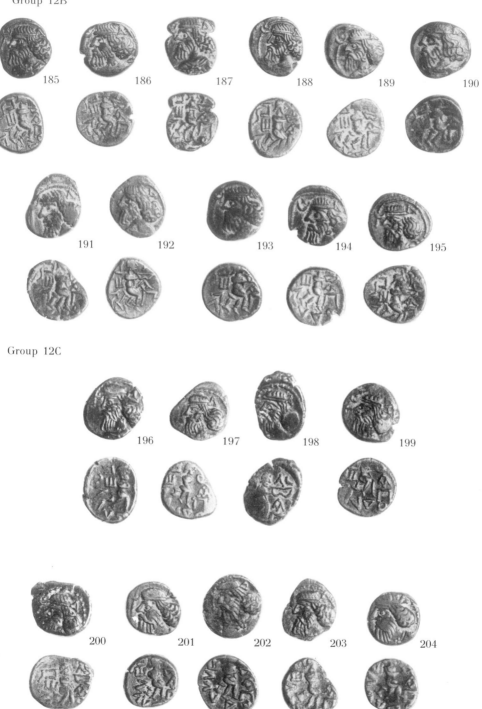

Group 12C

Plate 10

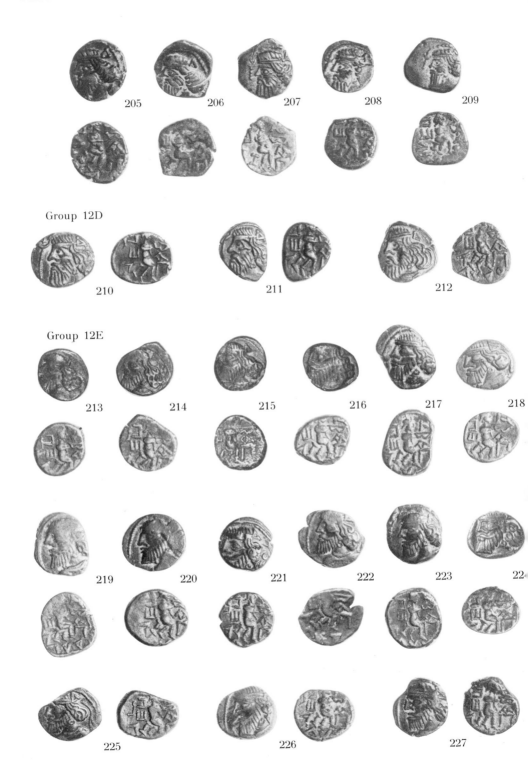

205　206　207　208　209

Group 12D

210　211　212

Group 12E

213　214　215　216　217　218

219　220　221　222　223　22

225　226　227

Plate 11

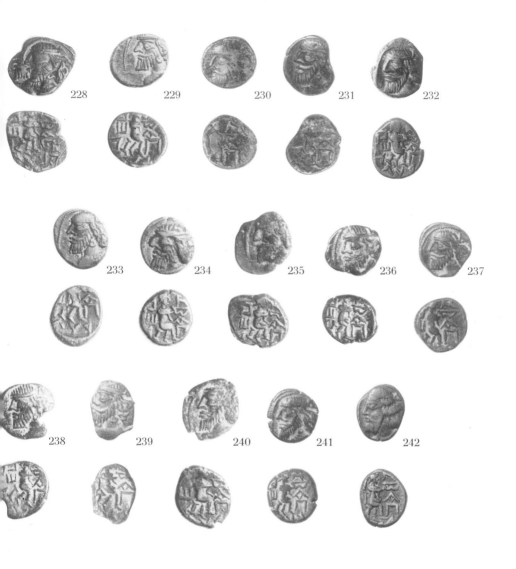

Group 12F

Plate 12

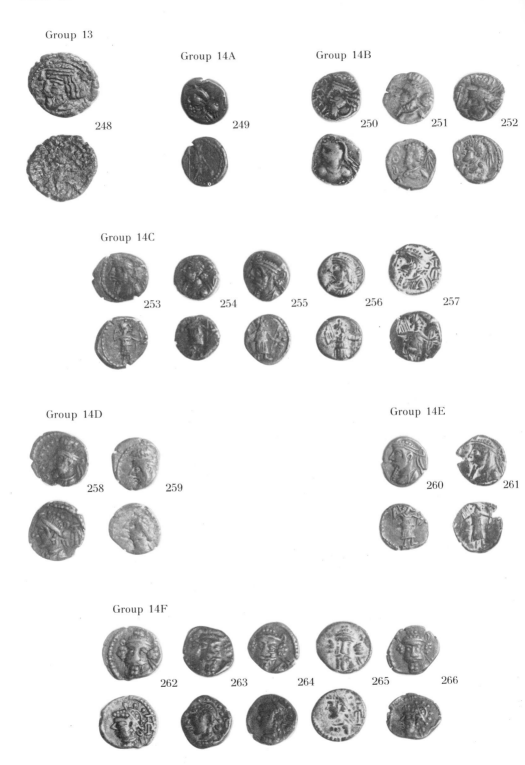

Group 13

248

Group 14A

249

Group 14B

250 251 252

Group 14C

253 254 255 256 257

Group 14D

258 259

Group 14E

260 261

Group 14F

262 263 264 265 266